Praise for *Displaying Organisation*

'Drawing on her wealth of experience in the field, incorporating all the latest thinking from the museum sector, Rhiannon Goddard takes you through the main stages of an exhibition project from the initial idea to post-project evaluation. In a truly valuable section on project management skills, she outlines the fundamentals for a successful project: programme, budget and risks. The book is full of practical tips from professionals, tried and tested techniques, templates and helpful online resources to refer to. Rhiannon's methodologies, which she explains in a clear and concise way, can be applied to any scale of project, temporary or permanent. This book is a wonderful resource, which I can highly recommend to anyone involved in creating engaging museum exhibitions.'
Amanda Hart, Roman Baths and Pump Room Manager

'This book accomplishes two things supremely well. Firstly, it provides affirmation for the experienced exhibition programme practitioner, and certainty to begin for the apprentice. Secondly, and this is the harder task, it conjures up inspiration for the producer and project manager; reminding them that engaging people, notably in history, is hugely rewarding and at its core, concerned with original creative thinking.

Few in the museums and heritage sector can outpace Rhiannon Goddard when it comes to multifaceted public programming project delivery. This book will up everyone's game, with the public being the main and rightful beneficiary.'
Andrew Lovett OBE, Chief Executive, Black Country Living Museum; Chair, Association of Independent Museums; Deputy Chair, National Museum Directors' Council

'Rhiannon has crafted a book that takes the reader on the journey of exhibition development and delivery, with people at the centre of the process. *Displaying Organisation* explores the crucial and wide-ranging role of the project manager, looking beyond the functionality of this vital position. Rhiannon successfully describes the collaborative process required to make an exhibition project a success, while balancing the needs of the organisation to take sensible business decisions. Rooted in pragmatism and relatable case studies this is a must-read for anyone working on exhibition projects – for those starting out in their career and the more experienced!'
Alex Patterson, Executive Director, Brooklands Museum Trust

'A must-read for anyone managing exhibition projects. There are many books on project management theory but applying that in the museum and heritage world is not always straightforward. *Displaying Organisation* is a book by a museum person for museum people. It not only presents a clear process for planning and delivering an exhibition but is also packed with wise advice, useful tips and practical examples. As you would expect from a book written by an experienced museum professional, it delivers clear learning outcomes! The well-defined and actionable framework, broken down into concisely written sections, will provide readers with the tools to manage projects in institutions large and small.'
Aileen Peirce, Head of Interpretation & Design, Historic Royal Palaces

'Step by step, task after task, sometimes exhibition project management can seem like going through the motions. Yet in this practical and readable guide, Rhiannon Goddard demonstrates how much more there is to managing exhibitions than simply ticking items off a checklist or overseeing workflow. The planning frameworks, management models and useful questions to ask ourselves are valuable tools for project managers, but this book also highlights the all-important soft skills required by effective leaders – listening to colleagues and contractors, stepping into the visitor's shoes, negotiating risk, staying hydrated during install, learning from each project we deliver and ultimately developing our own authentic management style.

Reading this book, it is clear Rhiannon has worked through these processes and questions a hundred times already; her lessons learned and wise counsel are invaluable advice for those working in any aspect of exhibition management.'
Steve Slack, author of *Interpreting Heritage: A Guide to Planning and Practice*

Displaying Organisation

Museum and Gallery Essentials

Series Editors:

Maria Blyzinsky, Heritage Consultant and co-Founder of The Exhibitions Team

Rhiannon Goddard, Head of Public Engagement Projects and Business Management, Historic Royal Palaces

Today's museum and cultural heritage professionals are multi-taskers, under pressure to operate efficiently and effectively in the face of many competing demands. There are rarely enough hours in the day to prepare well for critical tasks and meetings. Taking time out to think things through and plan properly can sometimes be seen as a luxury, which can lead to feeling overwhelmed by the tasks ahead. In addition, today's fast-paced world can throw up unforeseen challenges – such as the lockdowns of the COVID-19 pandemic or economic downturns. We may not be able to predict every challenge, but we can develop creative and critical thinking to help with problem-solving.

Museum and Gallery Essentials taps into the expertise of established professionals from across the sector. The series provides guidance that supports practitioners managing today's complex situations and challenges while also providing students with the frameworks and knowledge needed at the start of their careers. Each guide is carefully crafted to provide a highly practical road map, helping readers to think effectively, creatively and strategically when solving issues under pressure and with limited resources.

The Editors welcome proposals from cultural heritage professionals across a range of topics, including approaches to decolonisation, tackling the climate emergency, interpretation, collections management and care, registration, learning and outreach, financial management and curatorship. For more information, please contact info@facetpublishing.co.uk

Displaying Organisation

How to Successfully Manage a Museum Exhibition

Rhiannon Goddard

facet
publishing

© Rhiannon Goddard 2023

Published by Facet Publishing
7 Ridgmount Street, London WC1E 7AE
www.facetpublishing.co.uk

Facet Publishing is wholly owned by CILIP: the Library and Information Association.

British Library Cataloguing in Publication Data
A catalogue record for this book is available from the British Library.

ISBN 978-1-78330-505-6 (paperback)
ISBN 978-1-78330-506-3 (hardback)
ISBN 978-1-78330-507-0 (PDF)
ISBN 978-1-78330-531-5 (EPUB)

First published 2023

Text printed on FSC accredited material.

Every purchase of a Facet book helps to fund CILIP's advocacy awareness and accreditation programmes for information professionals.

Typeset from author's files by Flagholme Publishing Services in 10/13 pt Palatino Linotype and Open Sans.
Printed and made in Great Britain by CPI Group (UK) Ltd, Croydon, CR0 4YY.

In memory of my dad, Gordon Johns, who always said I would write a book, although I am not sure this is quite what he had in mind!

Contents

Figures, Tables, Boxes and Case Studies

Figures

Tables

Boxes

Case studies

About the Author

Rhiannon Goddard has been working in museums for over 20 years. She is a specialist in managing complex creative multidisciplinary projects that require cross-organisational collaborative working. Since 2008 she has been at Historic Royal Palaces (HRP), managing the implementation of major exhibitions including 'Royal Style in the Making' and 'Fashion Rules' as well as overseeing capital works such as the first phase of refurbishments of the King's State Apartments at Kensington Palace. As Head of Public Engagement Projects and Business Management she has fulfilled the role of Project Director for major installations, including 'Superbloom' at the Tower of London for the Queen's Platinum Jubilee in 2022 and 'Crown to Couture' at Kensington Palace in 2023.

Rhiannon is Deputy Chair of Trustees for the Association of Independent Museums (AIM) which works to help heritage organisations prosper. On the board she has fulfilled the role of inclusivity champion, working to ensure that AIM and its members tackle inequality and raise awareness of the responsibility of organisations to carry out their purpose for the benefit of all.

Prior to working for HRP, Rhiannon worked at the British Museum as the Interpretation Manager, overseeing the content production for major exhibitions including 'The First Emperor: China's Terracotta Army' and 'Hadrian: Empire and Conflict', as well as the refurbishment of several permanent gallery collections. She also ran a project to update the museum signage and gallery introductions.

Earlier in her career Rhiannon was the Lead Development Officer for Museums in the South-West, working for the Museums, Libraries and Archives Council and overseeing major grants programmes and the museum accreditation scheme in the region. She began her career at Somerset House Trust in the Education Department. She has an MA in History of Design from the Victoria and Albert Museum/Royal College of Art.

Acknowledgements

I couldn't have written this book without the help of all the colleagues and friends whom I have worked with over the years who have shared their knowledge and time with me. I have been very lucky to work in and with some of the greatest museums, large and small, in the UK and I hope that this book will inspire and help others to continue to make history and heritage interesting, accessible and engaging for all.

There are of course a few people whom I need to single out for their specific help in getting me through the process of writing this, my first book. First, Maria Blyzinsky, who asked me to review her own excellent book proposal for a title which looks at generating ideas for exhibitions and therefore got me thinking that perhaps I could also write about my experience of managing exhibitions. Her book on the creative process of exhibition planning will be part of a series of which we are both editors and which we hope will grow into a practical source of knowledge for museum and heritage professionals. Then there is the team at Facet Publishing including my editor, Pete Baker, who put up with my repeated requests for extensions with such good grace and supported me through the dark times of a COVID-19 lockdown when I thought I would never get the manuscript finished as there were no libraries open! And Michelle Lau who has done such a great job of pulling my manuscript into shape.

A number of people provided me with additional advice and support during the writing of this book, in particular Aileen Peirce, who read and provided insightful comments on my draft text, and Rebecca Richards and Nick Gold, who provided some top tips. Caterina Berni and Emma Bell allowed me to adapt their excellent interpretation plans and Claire Edwards generously shared thoughts on interpretation experimentation at the British Museum. Also providing me with support and inspiration were Eleanor Chipperfield, Jo Ingram, Alexandra Kim, Adrian Phillips and Steve Slack.

Thanks are due to the following organisations that allowed photographs of their displays to appear in this book: Historic Royal Palaces, Leeds Castle, National Museums Scotland and the Port Sunlight Heritage Trust.

Finally, I want to thank my husband, Stephen and my son, Bryn, who put up with me writing at strange hours and banishing them from the house over several weekends while I got the manuscript into shape. Thank you for putting up with me!

Introduction

This book grew out of my years of experience of running varied projects, not all of them exhibitions at Historic Royal Palaces, where I have been based since 2008. Before this, I worked as the Interpretation Manager at the British Museum, and even further back as a Museum Development Officer in the south-west of the UK. My experience has been varied, seeing museums of all sizes and types develop innovative exhibitions and put on excellent displays. As well as understanding the theory of project management, I urge you to get to know the sector you have chosen. Go to as many exhibitions as you can and learn from them what works and what doesn't work for the visitor; talk to the staff involved in putting them together and those involved in their operation, and learn from their experience. Being a good project manager (PM) can be learned through theory, but being a great one takes a passion for the sector and a deep and thorough understanding of how people react to pressure, deadlines and the fast pace of project implementation. On each project I am part of I learn something new about myself and about the process of successfully seeing a project through to completion. I hope this book helps you on your journey and I wish you success in achieving the satisfaction that comes from seeing a project successfully completed.

In the following chapters you will learn all about the skills and techniques you need to be a successful PM. Being able to manage projects is an essential skill for working in the museum and heritage industry. Although these skills aren't always formally taught on heritage management courses or required in job descriptions, they are in use by museum staff every day. All exhibitions are projects; moving a collection to a new store is a project; carrying out research for a book and writing it is a project. But often these tasks aren't described as projects, or perhaps your museum isn't familiar with the process of project management and therefore the steps taken to plan an exhibition successfully aren't formalised. Most people have to pick up these skills by trial and error. This book will provide you with the skills to apply traditional

project management techniques and processes specifically to the work of exhibition creation; but these are transferable skills that can be applied to many common tasks within the museum environment. So, I hope that this book will be useful to a range of people with many different roles working in the museum and heritage sector. Some of these skills are 'hard' skills: how to manage a budget, create a risk register and plot out the work needed to achieve your goal. Some are 'soft skills': to be a good PM you need to lead and to facilitate, to establish and provide excellent communication between team members, upwards to your manager or boards and between departments such as operations and curators. This book has been designed for you to dip in and out if you are working in the sector already or if you have some project management skills but want to brush up on a specific element; or, for a more comprehensive overview, you could read it from cover to cover.

A note on terminology

Throughout this book I will be referring to museums. I have used this term to cover not just traditional museums but also heritage sites, country houses that put on displays, art galleries and community-led spaces. Anywhere that mounts an exhibition, by which I mean a temporary or new permanent display involving objects or artworks put on for the benefit of the public, can use this guide to improve their practice.

So, what is a project and what is project management? There are many definitions, as a Google search illustrates:

> All projects are a temporary effort to create value through a unique product, service or result. All projects have a beginning and an end. They have a team, a budget, a schedule and a set of expectations the team needs to meet. Each project is unique and differs from routine operations – the ongoing activities of an organization – because projects reach a conclusion once the goal is achieved.
>
> (Project Management Institute, 2020)

> **Project management** is the application of processes, methods, skills, knowledge and experience to achieve specific project **objectives** according to the project acceptance criteria within agreed parameters. Project management has **final deliverables** that are constrained to a finite timescale and budget.
>
> (Murray-Webster, 2019)

> [A] temporary organization that is created for the purpose of delivering one or more business products according to an agreed Business Case.
>
> (The Stationery Office, 2009, 8)

There are a number of things in all these definitions that are consistent.

1 They are time specific. You have an end date, this is not business as usual (unless, of course, your job is in project delivery, like mine!). In the case of exhibitions, the end of the project is clear: it is the opening date or, if you are doing full life-cycle planning and your display is temporary, when you finish your de-installation after the exhibition is over.
2 They are unique. Yes, all exhibitions are different and will have their own specific risks, budgets and timescales; but, as we will see in this book, they all have some common elements which we can apply across these unique endeavours.
3 All projects have some element of risk to them and usually bring together a group of people who don't always work together. Making sure that you can manage this situation requires certain skills that we will look at as each phase of planning is discussed.
4 They have dedicated allocated resources, whether these are time, money or materials or even people. These need to be agreed and committed to by your museum, even if it means that line managers need to rethink their department's work to allow their staff time to work on the project.

In traditional project management there are usually four or five stages. This book uses the terminology shown in Figure 0.1 to describe them.

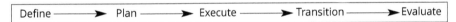

Define ⟶ Plan ⟶ Execute ⟶ Transition ⟶ Evaluate

Figure 0.1 *The stages of a museum exhibition project*

I will focus on a linear project management system (also known as critical path planning or waterfall), where each stage leads to the next and at the end the project is closed. This is a very traditional way of planning a project and, as is pointed out by the Association of Project Managers, it is 'suitable for stable, low risk environments' (Murray-Webster, 2019). Although it may not feel like it at times, this is the environment in which exhibitions generally operate. There are other types of project life cycle that you may want to explore if you run different types of project. These include Agile, where work is organised in short sprints, where each following sprint isn't defined until the end of the current one. You may switch to using a more agile approach for a specific element within the exhibition project, such as the creation of an interactive feature. Alternatives such as Agile are not the focus of this book, as most exhibitions don't use them. Exhibitions really are critical path projects, where the need to secure loans and create stable environments for objects lends itself to linear project management.

Stages of an exhibition project

For the purposes of understanding the role of the exhibition PM, we will start with the assumption that the idea for the exhibition has already been approved; in formal project management terms, we will start when the mandate has been issued. There is another book in this series, dedicated to this part of the process, and you may wish to refer to *Unlocking Collections* by Maria Blyzinsky. For now, though, we will start with defining and working up that approved idea and taking it all the way through to the end of the project in a five-stage process. To assist with this, I have divided the book into parts. Parts 1 to 5 relate to the five stages of the process, while Part 6 focuses in on the key skills of managing the programme, risks and the budget.

Define

This is the stage of the project that happens before 'project management' kicks in. For exhibitions this is a really crucial phase of your planning. The success of your project will depend on spending time, thought and energy on getting the definition right and setting the objectives. This is a piece of creative work, and is not easy. It can be tempting to jump over it and dive into solution-focused thinking and solving problems using design ideas. However, the best exhibitions have a sound theoretical and intellectual grounding which has been tested on peers and potential audiences, and when they are developed this shines through in their consistent messaging and popular appeal.

Plan

Once you have defined the exhibition, you need to figure out how to do it. If you skip this stage you will run the risk of creating confusion in the project team, which can cause problems with decision making and governance. This is also the stage where you start to add some timescales to your plan. At this stage you should be thinking about who will be responsible for each activity and what it is likely to cost. There are many processes and tools that can help you. We will explore these, together with some templates to assist you if you are starting out in this field. We will also look at getting the concept design ready so that you can show your stakeholders not only how you will manage the project but what wonderful things you are going to produce.

Execute (sometimes called delivery)

This is the stage when the project really takes off. More people will be working on it, and it is time to put all that planning and careful thought into

action. You will need to consider health and safety, how you will manage the site and the process for managing change.

Transition

The exhibition is ready! It has now become part of the everyday business of the museum. Here we will look at how you can make the transition from project to business as usual as smooth as possible. This is a short stage of the project, but a crucial one. A good handover (or transition) to those who will be running the exhibition on a day-to-day basis will mean that they and the visitors will have the best experience when the show opens.

Evaluate

What have you learned? What will you do differently next time? How well did you meet the objectives you set out in the define stage? Have you succeeded? How will you record what you have learned and how will this change your process next time? How will you share this knowledge with others in your institution so that you all practise continuous improvement? What do the visitors think, and how will this influence further work and other projects?

What is a project manager?

In many museum settings the role of PM is not a stand-alone one but is assigned to someone who also has another role on the project, such as a curator or interpretation specialist. In larger institutions the role may be fulfilled by exhibition managers. However the role is assigned, it needs to be filled by someone who has the skills and experience to plan, manage and lead the project from conception to completion. As highlighted by Dexter Lord and Lord (1999), 'There is a tendency to equate the word project with a task that is in its implementation stage' (our 'execute' stage), but it is essential for the PM to be involved from the conception stage of the exhibition, as they will need to advise the decision makers on whether it is possible to manage the project within the parameters that have been set for it, be that the timescale, the cost or the skills and available time of the people assigned to make it happen.

The PM's role is one of leadership: they have to co-ordinate work between teams, communicate clearly and effectively, understand the project in enough detail to be able to chase progress and be able to audit the work as it is completed. They are also responsible for identifying any problems or

blockages in getting the work done, and need to use the project governance structure to obtain support or clearance from their superiors. A PM is responsible for ensuring that the project is completed on time and within the budget allocated, and, crucially, that it is completed with as little disruption to the rest of the museum and its operations as possible. A good PM should be able to motivate staff, particularly when projects get tough, should be fair and, overall, should hold the vision for the exhibition and carry its implementation through to the end. It's a tall order, and you will need to find allies to help you achieve this – people you can trust to help you with your communication and to discuss project issues when they arise.

Being a PM can be a tough role, but it doesn't have to be a lonely one, as often you and your team form bonds as you face the challenges of getting things done. This will happen if you bring your authentic style to the position, take considered decisions and listen to what people around you are saying about the project and your management style. Use every project as a learning opportunity and have an open approach. Take timely, well-considered decisions and provide a clear vision for your team. These actions, along with some humility (everyone makes errors!), will soon earn you the team's respect and trust.

In conclusion, as a PM you should use each project as an opportunity to learn and to continually improve your communication and management skills. No one is ever finished with improving, but you should enjoy each project for the different skills you use and the variety of content, interpretive devices and team interactions you encounter. The same is true for the museum or institution you are working for or with: projects can be a catalyst for change, allowing the museum to grow and develop, whether that is in terms of the way they project manage or, on a larger scale, the way they present themselves to their visitors. The world of exhibitions is changing year by year, with new ideas on presenting information, telling more varied narratives and focusing on new areas such as sustainability, inclusive history and well-being. As a PM you have a key role to play in enabling curators, interpretation staff and all the other individuals working on the project to express and develop their own and your creativity. Enjoy it!

DEFINING THE PROJECT

In Part 1 I will be giving you some idea of the work that needs to happen before what is traditionally thought of as project management kicks in. We will look at how you define your vision for the exhibition and will consider how you will manage the project once it gets going. It's possible that you will be brought in as a PM after this stage has been completed; but it is worth knowing what will or should have happened already so that you can avoid asking the project team to repeat work they may have done already and so that you can help the museum to test some of the assumptions it may have made.

Getting the Vision Right

Introduction

Getting the outline vision and objectives of the exhibition right so that it appeals to the audience and aligns with the museum's goals is crucial, but is often overlooked as part of the exhibition process and isn't always part of a project plan. Projects run much more smoothly if time is built into the programme for this work. You will need to allocate time and resources; it doesn't necessarily need to cost a great deal, but it does need thinking time. If you skip this stage and dive straight into designing the exhibition this can lead to a confused narrative, problems in selecting objects and even being forced to change designs later in the process so as to accommodate ideas or narrative concepts that could have been planned for before you got going – adding cost, causing delays and making your life as the PM much harder. Having a really clear vision of what you want to achieve will save you time and, ultimately, make the exhibition better. Ensuring that it fulfils the museum's vision and goals is a must. So how do you go about this? This chapter proposes a number of steps for coming up with, testing and refining the exhibition idea. It includes information on how to manage the creative process and establish an outline narrative, how to consult so as to ensure that the idea works and how to analyse the ideas so as to create meaningful and actionable objectives for the project.

The creative process: coming up with the right idea

The first stage is coming up with the overall idea for the exhibition – thinking about and generating, developing and evaluating ideas. Often this stage is completed before a PM is brought on board and ends with a simple outline proposal, sometimes called a mandate, which is approved in principle for the next stage of development. This is the point where you as PM are most likely to be tasked with taking the project forward. This part of the process –

generating these first creative ideas and coming up with an idea, theme or central concept for an exhibition – is covered by another book in this series, *Unlocking Collections* by Maria Blyzinsky.

If the idea is approved for inclusion in the museum's exhibition schedule or for further development, it is usually given to a team to develop further. This may be done either through a formal mandate document or informally via a verbal or e-mail instruction. At this point a PM is usually assigned or is needed to plan out how to turn the vision into a reality.

It may sound obvious, but before you can begin planning an exhibition you need to know what it is about. Yes, you may have an outline idea, but you need more than this to create a full exhibition proposal. Figuring this out properly, carrying out the curatorial research and testing it with your prospective audience takes time, thought and creativity. It can be difficult to apply a process to a creative exercise, but it is possible, and it can really help to set some boundaries. The most important boundary for you as PM will be to settle on a timescale. Agree with those working with you on this task: how long will you give to the exploration of themes and ideas? The possibilities are often endless, but your deadlines shouldn't be.

This stage of defining your big ideas should be a creative and collaborative process, and it needs to be complete before you start thinking about design or writing text. This is the time to really think hard about the content, why you are doing this exhibition now, what you are trying to say, what you want people to think, what questions you are asking, what you do and don't know. Is this new and different in its approach? What is the core message you want to get across with the show? Be brave. Do your research, find examples of where others have tackled similar subjects well, see what can you learn from them and consider what you would do differently and how you will make sure that your exhibition stands out.

You may emerge from this process with a working title, strapline or sentence that sums up what you are trying to achieve. It is likely that these will evolve and change as you proceed with creating the exhibition, but they will be a good starting point and will help you in defining your vision succinctly.

Interpretation

Next will come the first part of your interpretation plan. Interpretation is a discipline within the museum and heritage sector that has been developing since the turn of the century, and interpretation specialists are now found in most national and larger museums, their role being to be the audience advocate and to work with the curator to come up with the best ways of telling a narrative for the target audience. Even if you don't have an

interpretation specialist on your team there will be someone who is responsible for writing the text and deciding what information makes it into the final design. They are doing the job of an interpretation manager. Interpretation specialists select which information makes the final cut, and they usually base their selection on two main criteria: the needs of the audience and the vision for the exhibition. For them to be able to do this they will need to be clear about the kernel of why you are doing this exhibition now and how it will link into the overall museum vision and forward business plan. This will influence the object selection and the narrative told.

There are many excellent books on interpretation planning, which is a discipline in itself, and there is more on interpretation in Chapter 3, including a further reading list. There is no one set way for museums and heritage organisations to plan their interpretation, but all the books seem to agree that you must not jump to thinking about the design solutions, or what Steve Slack (2021) describes as the 'interpretive toy box'. It is all too easy to start to think about the *how* before really considering *what* it is that you are trying to achieve with the exhibition or display. It can be hard to step back, and some people do need some concept visuals in order to start imagining how the exhibition might work – but if this is the case, try to keep to a general idea of look and feel, rather than getting drawn into specifics.

Question the idea

Let's take a theoretical example. You have been given a permission or a mandate that says the museum should create a display to mark the anniversary of a famous local figure. This might sound straightforward enough, but consider how your angle on interpretation can be made different from what already exists. As PM you will need to bring the curatorial and interpretive sides together to help you negotiate and test ideas. For example, will your exhibition focus just on the person's work that made them famous? Will you include elements of their private life? Will you include reflections on their legacy, and whom will you ask to provide this? Experts? Local people? Are there elements of the person's work or life that are less well known that you want to focus on? Are there areas of the story that are contentious or have not been discussed in the past and that reveal a different perspective on the popular narrative? Will you unpack these elements, and if you do, will you bring in partners from relevant communities to help? What sort of information does your target audience already know about this person, what interests them and how will you address this? Have there been exhibitions about this person before? How will your exhibition be different? How can you be creative in telling this story? Why will people want to visit

your exhibition rather than read a book about them? Who will the visitors be? Will they be families? Will they be young adults? Will they be different from your normal visitors? Will they have to pay, and how will this affect the visitor demographic? Can you source objects to answer these questions?

Your first step should be to create a log of all these questions so that you have them recorded and can start to resolve them. You may want to divide them into content-related questions and practical questions to do with resources or spaces. You probably can't answer all of them yet, but this will be a start. At this stage you may want to create your list of questions as a mind map. Later on you can create a shared log, perhaps in a spreadsheet or using an online tool like Teams or Trello to record all the unresolved questions that come up in team meetings. This will be an invaluable tool as you progress through the project, allowing the team time to record and think about the issues raised in discussions with designers or that keep you awake at night. For more about issues and risks and how to manage them, see Chapter 11.

All these questions can become quite overwhelming, and this is where you, as PM, need to bring together a group of people to support the curator and/or interpretation manager and start building a core team. Often at the start of the process you will find that many people want to get involved. It is great if there is early enthusiasm, you as PM need to consider who is right to be involved at each stage.

Carrying out consultation
Creative workshops

It is a good idea to hold a creative workshop on the narrative and subject matter of the exhibition as a way to get input from a broad range of people while still keeping the core team small – usually curator, interpretation specialist, someone from your education team, a front-of-house representative and, if you have them, a conservator. Remember, and remind others, that you are not designing the exhibition at this stage but are exploring the angles, objects and information about the subject and preparing some ideas for the focus of the show.

Depending on the subject, the time available and the willingness of participants to explore alternatives, you may just need one workshop to get this right, or a series. This is where you will need to become a facilitator and leader, or perhaps to bring in a workshop facilitator to help you. PMs don't always need to lead the work, but are usually charged with finding the right people to help.

Preparation for the workshop is important. You may want the curator to give a short talk about the subject, or to involve some peers from other

institutions with specialisms in the area that you are considering so as to bring fresh ideas and challenge your thinking. You may want the exhibition to have a strong link to your communities and will thus need representatives from those communities to help you decide on the core narrative or theme. You may need to provide images of the key objects or to organise a tour of the stores. You will need to set aside times for discussion and for recording the input and ideas that are generated.

Start preparing for the workshop by planning out the time. It is a good idea to break it up into short presentations designed to provide a quick shot of interesting information and help stimulate the participants, and time for structured discussion. Make it fun, have the participants move around and mix, and keep everyone energised with plenty of tea, coffee and biscuits. Beforehand, practise talking about the exhibition and subject matter, and focus on defining the questions you want answered. These questions will come from your list of issues or your mind map.

A mind map is a simple way of recording lots of ideas, to which your core team can all contribute (see below for more on mind mapping). Start with the theme in the middle and draw a line out from it for each idea that you have. Then start grouping the ideas into themes for discussion. If at this early stage you get the questions right (open, exploratory and backed up by subject and audience knowledge), then you will find that the workshop will provide the results that you need, so it is worth spending time on it. Encourage the participants to be positive and open, and to accept that, at this stage, there are no bad ideas.

Workshop challenges

Workshops can become derailed and ideas can be killed off before being given proper consideration if colleagues become focused on operational details and difficulties, so try to steer people away from these kinds of discussion and give every idea a chance to be considered without prejudice. Be wary of comments like 'we tried this before and it didn't work' – question why, and find out if the reasons are valid or if it is just a reaction to a proposed change. Ask the participants to set their worries aside and focus on evaluating the idea, not trying to imagine it in the space.

It can be difficult to negotiate your way through a workshop. Coming up with ideas isn't a linear process; it is usually a bit chaotic and can feel unfocused. If you are the facilitator, hold your nerve during such moments and listen carefully for ideas that have meaning. Listening is the most important skill to cultivate as a PM. Throughout the project people will tell you things that you will understand only if you are really listening. For

example, if something isn't going well you may not be told outright; you have to learn to ask questions and listen carefully to the answers.

You will probably emerge from this creative workshop process with a few different outline narratives or perspectives that you can match to your available or potentially loaned objects.

The development of the interpretation plan and the object list is an iterative process, usually involving a series of workshops throughout the concept design period to define areas of the narrative or interpretation. As PM you need to make sure that this process of iterative changes is incorporated into the stage of the design process where changes and updates can be made without causing problems to the overall project plan or budget (see Chapters 2 and 10 for more on the process). Equally important is that you ensure that these discussions are drawn to a close at the end of concept work to allow the project to move on to more detailed design.

Box 1.1 Using mood boards

Mood boards are often used by designers to provide inspiration for the creative process. They can be physical or digital (Pinterest for example). Many materials can be placed on a mood board: images, writing, fabrics etc. each chosen to help those working on the project better understand the concepts. Over time a mood board can start to outline a visual language for the exhibition.

Being from an interpretive background and something of a visual learner, I find it useful to work on a mood board. Having pictures of the key objects for the exhibition and pinning them up in groups to match the narrative helps me to picture which narratives work best and are well represented by the available objects. I like to then match the objectives to my mood boards to check the ideas haven't moved away from the central ideas.

You may want to try different techniques for creating a mood board; for example, writing ideas on Post-It notes and pinning them next to object images, or even working in the museum store, recording your discussions about the objects and then adding sound bites from your recording and to the images on a large pin board. Try things out and find a method that works for you.

You are unlikely to hit on the final vision for the exhibition in just one workshop, so include time in the schedule to revisit discussions. At this stage, just remember to keep things focused and not to stray into actually designing the exhibition – this will come later. This is why creating a mood board is so helpful: it gives a visual focus without trying to design.

Test your ideas in house

Once you have narrowed down your ideas, invite people in to see the mood boards, or circulate the typed-up discussion or Post-It note ideas and get others to discuss the narrative with you. This could be a good moment to invite in other specialists in the subject, and also to share your ideas more widely among your front-of-house colleagues, who often have extensive and very useful insights into what visitors and members of your target audience want. Check that you have new research or a new angle on a subject, so as to make the exhibition fresh.

This is also a good time to invite in some of your senior stakeholders, those who will be signing off the exhibition and your work later on. As you develop your ideas it is important to test the water with these stakeholders; the last thing you want is to get to the end of this in-depth piece of work, only to be told it isn't what they were looking for. Make sure that you involve them all the way through and show how you are dealing with their comments and suggestions. Work with them to bring them on the journey of developing the ideas.

Testing ideas on your audience

As part of the planning process you will need to think carefully about who the exhibition is aimed at – your audience. In order to do this, you will need to know who your visitors, users or customers are and their motivation for visiting. Who are the core visitors who already visit you, and who are those that don't but whom you would like to attract? These groups are usually defined in an audience development plan, which is part of your museum's forward planning and its vision for what it wants to be. Most museums keep some sort of data about their audience, whether it is simply numbers coming through the door or a full segmentation of visitors by motivation and demographic indices, right down to the newspapers they read. The field of visitor studies is well established and there are individuals within museums who specialise in analysing the data collected from visitors, as well as commercial companies that have developed models specially to assist the cultural sector in getting better insight into their users. If you don't have access to any of this support, you or someone in your team will still need to consider the audience you already have and those that you may want to attract to your exhibition. It is time to do a bit of research.

Find out where the majority of your visitors come from, what they say they visit for, and start to think how this maps to your exhibition and its goals. Why people visit and their behaviour while at your museum will be a driver later on, when you start planning how to impart your narrative to them. Most exhibitions need to balance the need to satisfy the museum's current audience

and to draw in new visitors. If you are aiming at a new audience, you will need to establish the interests and needs of this as yet untapped audience. Why don't they visit? Even if you do put on an exhibition, will they come? Is it better to try to encourage more of your regular type of visitor? If you change things, will this alienate your core audience in favour of a new audience? Is this acceptable? Can you balance the needs of both the current and the new? Note down your conclusions: they will help you to form the goals and objectives for the project.

Testing your ideas on the audience will ensure that you are appealing to the market and that the level of information that you are planning to provide is right. Too often, over-familiarity with a subject can lead to an exhibition including a lot of implied knowledge, which will leave the majority of the audience feeling alienated, unconnected and frustrated – which is not the outcome you want! It is essential to remember all the way through the exhibition process that this is about the visitor; not about creating something for your peers or for you, but for the audience. If that means that you need to explain what seem like obvious concepts or ideas, then you must do so, and allow space and time for it.

There are many ways of testing ideas on audiences through *formative evaluation* processes. These do not need to cost you lots of money, but it is worth investing time in the process, as those exhibitions that resonate with their audience always do best. The remainder of this section presents some basic techniques that you can use to test your ideas. They can be done in house, but if you want statistically robust evaluation you will need to put resources into this. You may be lucky enough to have someone on the team who is an audience or research specialist, but it is likely that you will need some external help to ensure that you exclude leading questions and that your sample is representative. You will need to allocate the task to someone with the necessary expertise to analyse the data collected and to provide the results in a usable summary.

Focus groups

Focus groups are one of the most common ways that museums test their early ideas on the audience. Getting in a group of users and targeted non-users, presenting your ideas to them and recording their responses will give you valuable feedback as to how your ideas will be received, highlighting areas that you may have missed, and giving you a great critical appraisal of your proposal.

Planning for a focus group takes time, as you need to give your group a clear and concise summary of what you are planning – but without resorting

to hyperbole or to leading or closed questioning. You will also want to find some way of engaging them with the ideas, and when the exhibition is little more than the germ of an idea in the heads of a small group of people this is hard to do! Here, visual stimulus is key, and it needs to be very straightforward and literal because, while we may be used to imagining a finished visitor experience from mood boards or verbal descriptions, focus group participants generally don't have this skill. To help them imagine your concepts, consider showing images and clips from other exhibitions or sites to illustrate points, and provide them with some easily accessible background material.

Case study 1.1: Focus grouping a Georgian kitchen at Kew Palace

A few years ago I was working on an exhibition which included the recreation of a Georgian kitchen at Kew Palace. The early creative process had produced two different ideas for how to present the spaces: one where we only partially restored the space, leaving some of the 'as found' atmosphere to it, and one where it was fully restored. Testing this on the focus group, starting with a short demonstration of Georgian cookery and images of other kitchen exhibitions to get the participants excited about what we could achieve with the kitchen space, revealed a third idea: visitors weren't too worried about a mix of the 'as found' and fully restored looks. Something that we had thought would be confusing or might lead to misunderstanding on the part of visitors actually worked really well. We ended up interpreting the downstairs spaces with minimal restoration, and recreating the Georgian offices upstairs. This approach was very popular with visitors, but without the focus groups we might never have considered it as an option.

Remember that, even with the help of an external facilitator, you will need to put in the work to prepare the resources needed to inform a focus group and get meaningful feedback.

Interviews

If focus groups aren't possible then some structured interviews may help to reveal audience responses to your emerging themes. Spending some time to put together some carefully worded open questions to establish visitors' – and perhaps even non-visitors' – thoughts on the subject matter and to find out some of their motivations and preferred interpretation styles can provide you with excellent guidance as you move into the next stages of planning the exhibition. These short interviews can be conducted by volunteers with minimal training, but they do produce lots of data that will need inputting, sorting and analysing, which requires time and expertise.

Mind mapping

This is a useful technique for exploring what your existing audience knows about your subject, and is easier to carry out in house than in focus groups or interviews. It takes only a few minutes for someone to fill in a mind map, but you will need to allocate time for analysis, usually entering the words into a spreadsheet and generating some graphs to show areas of repetition that identify a baseline of knowledge or expectation about a visit.

Start with the subject you want to explore at the centre of the page. Then, if you have a number of ideas, divide the page into segments, one for each of the ideas you have for the core vision. Equally, you could create more than one map (one per idea) and compare how visitors react to each map. The map is then annotated by the visitor to provide a snapshot of the headline information they already know about the subject.

Case study 1.2: Mind mapping at Hampton Court

For the creation of a new display at Hampton Court about the part of the palace built after 1689, mind maps were used to test visitors' familiarity with the terminology that might be used in the display. The aim of the evaluation was to discover visitors' familiarity with topics and what they would like to learn more about. Two sets of mind maps were completed by visitors, using different terminology to see if this affected their responses. One centred on the Georgians and the other on the term 'baroque'. Visitors were given two pens of different colours and asked to use one to populate the map with what they already knew about the period (mainly the names of monarchs – which weren't always correct!) and what they would like to know more about (mostly socio-economic information such as fashion and what life was like). It was found that people were more familiar with the term 'Georgian' and this was easier for them to place within their existing knowledge of history.

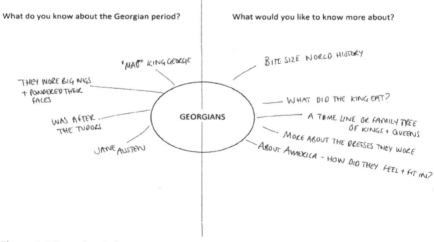

Figure 1.1 *Example mind map*

Mind mapping can also be used in summative evaluation where visitors fill in the map before visiting the exhibition and then annotate it in a different colour afterwards with the additional information they have picked up, learned or remembered while visiting the space. Although this will give you a basic overview of your visitors' knowledge base, it won't tell you much about their views on the exhibition.

Tracking

If you are redeveloping a gallery you may want to try some visitor tracking to see what objects people are most attracted to, or how they move round the space in its current layout. With a simple plan of the space on a clip board, sit unobtrusively in a corner of the exhibition space. Track visitors around the space by drawing lines on the map to show where they go and marking on the map how long they spend at individual exhibits. If the space is busy, try tracking every third person so as to avoid repeatedly picking the same sort of people to track. The resulting map will show you how the gallery is working. Are there areas that people miss, and why do you think this is? Perhaps they are hidden by other exhibits, or perhaps they aren't eye catching enough and don't draw people in. What is the flow like around the space? Are there objects that are particularly popular, and could you use these better to move people from one area to another?

If you do use this technique, remember to inform visitors at the entrance that evaluation is taking place. It is a good idea to combine this work with either focus groups or structured interviews to get some feedback on what people think about the display. This sort of information will be especially useful when putting together your full interpretation plan (see Chapter 3).

In-house knowledge

In your work to develop the idea for the exhibition you should already have someone from the operational side of the museum on your team. The front-of-house staff talk with visitors every day and have a vast amount of knowledge about what visitors already know. They can tell you what questions they hear over and over again and would like to have explained by the display so that they don't have to constantly repeat themselves. They know how visitors move around the space, what they commonly look at and what they seem to like and dislike. Don't dismiss this intelligence, as it is priceless.

Refine your ideas

By combining the workshop results and any formative evaluation, and working with your colleagues, you should now be able to narrow down to a central idea for the exhibition. Once you have completed this – recording the ideas that you will discard and why they are being shelved as well as noting those you will keep – you will be much closer to knowing what will go into the exhibition and what you should leave out.

This is the moment when the curator can start to refine the long-list of objects that fit the idea, the list that will start to form the basis for the interpretation planning and hierarchy. It is unlikely to be the final list, but it will help to bring the vision to life and give a flavour of your ambition for the display. Once you have the objects listed and your ideas refined, it is a good idea to write an exhibition vision summary. You need to write an 'elevator pitch' or pithy paragraph which will 'sell' the concept of the exhibition clearly and succinctly to anyone who asks about it. Your challenge as PM is to balance the new ideas with realism about the physical space and cost, and to start to judge and help others to judge what is actually achievable, given the available time, budget and resources (people, objects and so on). You need to distinguish between what is an opportunity or a new idea that will bring real value to the exhibition and its audience and what is 'scope creep' – adding everything possible just because you can. To help you judge if something is scope creep, return to your original objectives and audience and ask whether this addition will really add value for the visitor and contribute to meeting the objective. Is it essential to the success of the show, or simply 'nice to have'?

The following are two examples of how the summary outline of your vision might look.

> **The exhibition will look at the life of the Roman emperor Hadrian, providing fresh insight into the sharp contradictions between Hadrian's character and the challenges faced during his reign (AD 117–138).**
>
> Ruling an empire that comprised much of Europe, northern Africa and the Middle East, Hadrian was a capable and, at times, ruthless military leader. He realigned borders and quashed revolt, stabilising a territory that had been critically overstretched by his predecessor, Trajan. Hadrian had a great passion for architecture and Greek culture. His extensive building programme included the Pantheon in Rome, his villa in Tivoli and the city of Antinopolis, which he founded and named after his male lover, Antinous.

> **A new film installation and display to mark the date when Her Majesty Queen Elizabeth II becomes Britain's longest-serving monarch, drawing parallels with the reign of our last longest-reigning monarch, Queen Victoria.**

The film installation will celebrate the reigns of Her Majesty the Queen and her predecessor Queen Victoria. Drawing parallels between the lives of two era-defining monarchs who have both presided over momentous changes in British history, the new display will explore key moments in the two reigns through imagery, including their strikingly similar coronation portraits by George Hayter and Cecil Beaton, their wedding portraits and images of both monarchs undertaking largely unchanged ceremonial duties throughout their long reigns: meeting world leaders and representing Great Britain on the global stage.

This is the point where you present your vision as what Serrell (2015, 6–8) describes as the 'big idea': a solid idea that grounds the exhibition, a refinement of your vision into one clear statement that sums up what the exhibition is about. 'The big idea provides an unambiguous focus for the exhibit team through the exhibit development process by clearly stating in one non-compound sentence the scope and purpose of an exhibition', and she gives some excellent examples, such as 'Fossils are clues that help us learn about dinosaurs'. This process is hard and takes time, and should form a key part of the interpretation plan (see Chapter 3 for more on this).

Set your goals and objectives

Once you have a better focus on the narrative you can start creating some objectives for the exhibition. These define what you are trying to achieve, and they should be SMART (Specific, Measurable, Actionable, Relevant and Timely).

Look back at your work from the first process to come up with some specific goals. Why are you putting this exhibition on now? How are you linking it to the museum's vision and how will the exhibition contribute to this?

Remember that most visitors aren't looking for a didactic experience – exhibitions are spaces for informal learning. Try to avoid too many of your goals turning into phrases starting with 'visitors will learn' or 'visitors will understand'. These kinds of objectives often lead to the creation of didactic displays or they are impossible to meet, as they are too nebulous or complex. If you don't have a learning specialist on the team, then look at the national curriculum (in the UK) and see how the exhibition can support its aims. To create some learning-specific goals, consider tools such as those found on the Group for Education in Museums website at www.gem.org.uk or at the Arts Council under the 'Inspiring Learning for All' framework (see Online resources).

Try to create a balance with your objectives. You will need a good mix that includes attracting visitors (how many and who), the wider impact of your

exhibition (the sort of press coverage you hope for) and learning objectives (such as visitors leaving with a richer understanding of a specific topic or topics). Include some emotional outcomes too, such as how visitors will find contemporary relevance in the narrative or make personal emotional connections.

Museums are places where visitors are often engaged through sensory experiences and social connections and where learning takes place away from a structured, formal or classroom environment. This doesn't mean that complex ideas or concepts can't be explored, but the objectives you set will define the type of experience that will be created. To create great objectives you need to have the visitor at the heart of your planning. Your objectives should mainly be about the visitors or audience. It is true that you may need to make money as well, but you won't do that unless visitors feel inspired to come and to tell others to visit.

Start with your goals, which could be things like:

- Increase the number of visitors to the museum.
- Grow our audience.
- Create a focal point for the community.
- Present an interesting new angle on the subject which will appeal to our target audience.

Goals are broad statements of outcomes you want to achieve and are often not measurable on their own. They may be something long term that the exhibition is contributing towards but will not achieve on its own. You may have a list of more goals than you will be able to achieve, and now is the time to narrow it down and get focused.

Once you have agreed on the goals, start to break them down into objectives. Objectives are the actions you will take as part of the exhibition to achieve your overall goals. The best way to test if those objectives are right is to make sure that they are SMART. This stands for:

Specific: You need to create something that is clear and can be applied directly or specifically to the project. For an outsider who has only a little knowledge about the exhibition, the objectives should be clear and understandable.

Measurable: You need to be able to measure what you are doing, otherwise how will you know if you have achieved it?

Actionable: The goal needs to be something that you can actually do. You need to work out what steps you will take to make this happen. This is where an objective differs from a goal.

Relevant: Whatever you are planning to do needs to be relevant to the exhibition and the museum.

Timely: You need to set a timescale within which to achieve each objective. When are you planning to finish and measure it?

For the goal of growing the audience an objective for your exhibition could be:

> To increase the number of family visits during the summer holidays from X to Y by focusing the exhibition design on being family-friendly, first testing it on the target audience. Testing to be completed by (date).

This is *specific and actionable*: it has two clear actions for the exhibition team to work on – designing in a family-friendly way and testing this on a target audience.

It is *measurable*: the success criteria are specified as the number of additional family visitors you hope to achieve.

It is *relevant*: your subject matter is designed so that will appeal to families and you are not trying to tack this onto an exhibition where the subject matter isn't appropriate for the audience.

It is *timely*: you have set a date by when the testing should be complete and a time frame for the increase in the number of family visitors (the summer holidays).

Make sure to include some objectives that relate directly to the emotions or outcomes you want visitors to experience. These are harder to measure, but an exhibition is all about the effect it has on visitors, so capturing this alongside the more literal objectives around visitor numbers and income is important. Make sure that you don't lose sight of the narrative that works the best for the audience and the content and vision. You will need to find the space where all three areas – goals and objectives, audience needs and content/information – overlap (Figure 1.2).

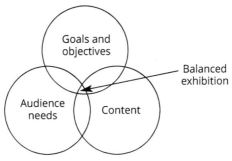

Figure 1.2 *Creating a balanced exhibition*

Creating objectives that are SMART isn't easy, but it becomes easier with practice. The main thing is to make sure that you create objectives that really matter to the exhibition and that will add some value to the museum when measured. Think about why you have chosen those specific goals and what you want to achieve through the display. It is better to have just a few well-chosen objectives than a long list. The danger of having too many is that at the end of the project you will look back and wonder why they were included. Objectives need to be really relevant and should be constantly referred back to by the project team throughout the process. They are your guiding light and will help you to achieve an outcome that is beneficial for both the audience and your museum.

Key dates

You will need to set some parameters for the exhibition. Start with key dates. Rather than writing a detailed programme, outline the dates and timescales that are most important, starting with the opening date and working backwards. Are there any key dates such as relevant anniversaries to consider? How long does it usually take you to plan and put on an exhibition? As you do more exhibitions you will probably have a better idea of how long different tasks take. As a general rule of thumb, each stage – design, concept, scheme and detailed – takes six to ten weeks, the length of each depending on the size and complexity of the exhibition. Leave adequate time for building any sets and installing the exhibition, and to gain any permissions that may be required such as planning permission, listed building consent, building control or even scheduled monument consent. Then add a bit more time to allow for the schedule to slip, as a rule of thumb I tend to allow about 10–15% of additional time to the overall programme if I can.

Consider any fixed dates, such as a funding agreement that has a deadline by which your project needs to be finished, and add these into the schedule. A simple table or list will suffice for this stage. You will create a more detailed programme as the project starts up – which you will be ready for once this initial planning work is completed and you have approval to go ahead with it.

Finishing the definition stage

Now that you have carried out this planning work you will need to put it into a format that can be used by the project team as a clear reference document summarising what you hope to achieve, and that can be approved by the project board or senior management team. This document is often called a

proposal, and it allows the team to start working in earnest on making the ideas into reality. It should sum up:

- the vision and 'big idea' for the exhibition, including an outline of its content showing how it is unique;
- how it will contribute to the overall museum vision and objectives;
- how it will respond to visitor needs;
- its goals;
- its objectives – so that they can be measured against at the end of the project;
- when it will happen (noting that most exhibitions take at least two years to develop and implement).

It should also contain:

- images of key objects, and perhaps some quotes or interesting information about the subject to help sell the idea;
- some examples of the types of displays that will serve as creative inspiration for the team.

You may want to include some idea of cost, but this really comes at the next stage, when you start to get some concept designs and to think about what you can achieve and how much budget the exhibition may need.

Once the proposal is ready you will need to get it formally approved. In project management terms this is called a gateway. A gateway is the moment your whole project moves from one stage to another. A gateway is also what is referred to in project management as a milestone, an event that marks the end of task but doesn't have time attached to it. You may have a number of milestones in your project but if you follow this project management framework you will make only five of those milestones into gateways (define, plan, execute, transition and evaluate). To move on to the next stage you must pass through this gateway and be able to prove that you have permission to continue. It is essential to keep a record of this, because if there are questions later on about why money was spent, or even about the content, you can refer back to the gateway moment and the recommendations and thinking of those with the decision-making power. Make it clear to the project board or senior management team that this is a decision point for them, and that by agreeing to the vision and objectives in the proposal they are authorising you as the PM to start working in more depth and with more people to get the work done. In our bespoke exhibition project management system I am calling this gateway 'Definition'.

The key to knowing when you have reached this formal gateway is the completion of the definition document, the exhibition proposal, which you will share upwards to the project board or senior management team for sign-off. The exhibition proposal should succinctly summarise your work so far, providing a clear and compelling case for why you should be allowed to proceed. You may be asked to tweak it or change some elements. If this is the case, once you have made those changes make sure to resubmit the document and get formal approval before you continue.

Gateway moment

On completion of the project proposal you will reach the first gateway of the project, when you present the proposal to the project board or senior management team and ask: 'Is this exhibition something that you, the museum, want to invest in, and do you agree that it meets the museum's objectives?' On passing through the gateway you will enter the project planning stage, which is covered in the next three chapters.

Let's summarise

By this point:

1 you will have been given a mandate to develop an idea that has been approved for further work (this stage often takes place as part of a larger process of generating and beginning to develop ideas for exhibitions or as part of the museum's overall forward planning);
2 you will have helped the people working on the idea to analyse it for all the different angles that it could have as an exhibition;
3 you will have facilitated or carried out a workshop or series of workshops with key staff/peers to find what angles would work best using the available objects and research resources;
4 you will have arranged and supported the testing of the ideas on some visitors so as to be sure that they have an appetite for the chosen angle and so that the content team will be informed about the knowledge level of the audience and can pitch the interpretation at the right level;
5 you will have helped the curators, interpreters and conservators to develop an outline long-list of objects and a core narrative idea or 'big idea' in light of the work with staff/peers and audience, coming up with a clear summary paragraph and defining sentence to describe early thoughts on the developing exhibition content;
6 you will have considered the objectives of the exhibition and made them SMART;
7 you will have identified key dates and timescales for the work;

8 you will have written up a summary of the work to date as an
 exhibition proposal and submitted it to your project board or senior
 management team for approval to proceed to more detailed planning.

PLANNING THE PROJECT

Now that you have a defined vision for the exhibition it is time to start planning how you will carry out the work to make the exhibition a reality. It is often at this point that a PM is assigned to work on an exhibition – although the previous chapter will have demonstrated how important it is for this to happen earlier in the process. The three chapters in Part 2 look at how to set up your project team, interpretation planning and the process of appointing and working with designers to create the concept design.

CHAPTER 2

Setting Up the Project

Introduction

This chapter is about the first tasks you will need to undertake to set up the exhibition project. Now that you have an agreed vision for the project (*what* you are doing) you need to consider *how* you will deliver and manage the exhibition. I will explain how to set up the key tools that you will use to govern and manage the project. Putting in the effort at this stage will make your life much easier when things start to get really busy. We will refer to this as the planning stage. This is the time when you make sure that you have the right people involved and formalise their places and roles in the project. If you were involved in the definition stage you may have already begun this work, but now you will need to formalise the team make-up and get each team member to commit to delivering packages of work for you. It is your role as the PM to provide the team with clarity about what is expected of them as the project progresses. The work you do at this stage will identify what tasks need to be done and, most crucially, who is responsible for getting them done. Agreeing on this at the start will avoid repetition of tasks by more than one person or, if the team is very small, will help you to be realistic as to how long it will really take to produce the exhibition. The team will work on developing the exhibition proposal into a more detailed brief or project description, which will not only spell out information about the content of the exhibition but also start to set out some of the parameters of the project. When all the elements described in this chapter are in place they will be a key part of what is known as the project implementation or execution plan (PEP). Essentially, this is the project handbook outlining how and when each element of the exhibition will happen.

What do you need to think about during this planning stage?

Finance

You will need to start thinking more seriously about the cost of the exhibition and how the budget will be used. You may already have been given a fixed budget, or you may have been asked to come up with an estimate of the cost. Either way, you will want to start thinking about both what the exhibition will cost and what income it might generate for the museum.

Estimating income

Start by estimating the amount of additional income it might bring into the museum. To get an idea of the uplift in visitor numbers that the exhibition might generate, look back at previous exhibitions and compare them to those times when there was no exhibition. If you have stated specific targets for audience growth, you can match these to the expected ticket, shop and café income. You will need to know the yield that visitors bring to the museum – that is, the average amount of money generated per visitor from ticket or other sales. For ticket sales, museums that sell tickets have a range of price points depending on the type of visitor; for example, some may pay £10, some £8. Consider also that some visitors may buy concession tickets or family bundles. You will need to work out the average cost of a ticket based on the percentages of each type sold across a period of time. Look back at previous years' income and visitor numbers to work this out and apply it to your calculations. For shop or café sales, some visitors will purchase more than others, so you will need to know what the average visitor spends. Once you have a yield figure, take the number of additional visitors you expect and multiply it by the yield. This will give you a rough guide as to the additional money that the exhibition may generate. How does this compare to expenditure? Is it essential that the exhibition makes money, or are its goals different?

Estimating costs

You may be asked to make an estimate of how much the exhibition will cost. At this early stage, when you haven't got any designs to cost against, your estimate will necessarily be very rough, but a ballpark figure will help you to explain to your team the level of commitment and input that will be required. If you are used to doing temporary exhibitions in a defined space in the museum, you can refer back to the costs of previous exhibitions and can take an average of these. If a lot of loaned objects will be coming in you may want to include additional budget to cover transport costs; or, if you aim to achieve a specific objective with the exhibition, you may want to consider whether this will require more than the usual spend. If you haven't done an exhibition

in that particular space before, then it gets a bit trickier. You could use a rate per square metre from the last time you did an exhibition; or you could contact colleagues in other institutions with displays of a similar size or of the quality you are aiming for and ask about their average expenditure per square metre. An internet search can also help, as some museums publish their costs and some square metre rates are available. Alternatively, try looking through back issues of the *Museums Journal* or other industry reports, as the exhibition reviews often include project costs and these can help you to envisage what your display might end up costing. Think about what the big items of expenditure are likely to be. For most exhibitions, the following items are usually at the top of the expenses list:

- showcases;
- set works: this term covers any intervention designed to transform a room with showcases into an experiential space. These interventions can be as diverse as false walls, creating rooms within rooms, lightboxes, cladding for showcases, plinths, large graphics sometimes called environmental graphics or even temporary architectural features;
- any audiovisuals (AV) or sound;
- lighting;
- infrastructure work to bring a space up to specification for a new exhibition, including new electrical work, lighting, data services and redecoration;
- transport and conservation of objects;
- mounts for objects;
- graphics;
- additional staff, if needed.

If you are unsure about any of these costs or the exhibition is complex – for example, it may require refurbishment works – then it is best to get some professional advice from a quantity surveyor (QS). There are plenty of firms that specialise in providing costings specifically for museums, galleries and heritage sites and they will charge only a small fee for initial advice. If what you estimate for costs will fix your budget and you have no previous data to work from, then it is best to call in the professionals. For more about managing costs see Chapter 10.

The business case

To create a basic business case for the exhibition, you then put all the figures together:

- visitor numbers;
- yield per visitor;
- exhibition cost.

At its most basic your calculation may look as shown in Figure 2.1.

Extra visitors generated by exhibition: 25,000
Average ticket yield per person: £4
Potential income: £100,000
Cost of the exhibition: £75,000
Income after costs: £25,000

Figure 2.1 *Simple example showing how to work out return on investment*

Major risks

Your next task is to start considering the major risks to completing the project, and this is where you will start the risk register (see Chapter 11 for information on managing risk). Risks at this stage will necessarily be high level and quite general. Some may jump out at you and be very obvious; others you will need to identify and prioritise.

As you have created a list of objectives for the exhibition, this is the time to start thinking about the risks you will face in achieving them. For example, looking at the objective of increasing the family audience, one risk might be that the museum's marketing doesn't normally reach this type of audience, and so families might not hear about the exhibition. Your risk here would be 'Marketing campaign doesn't reach intended audience'. You then need to think about how you will tackle that risk – how you will mitigate it. In this case the answer might be 'work with local schools to distribute information about the exhibition before they break up for summer', or 'employ a marketing agency to target the family audience'. You will want to add a note here that this may mean extra costs.

Look back and think about previous exhibitions that you have put on. What things went wrong? What were the major challenges? Were the risks things that you could have anticipated? Are they ongoing? How would you tackle them if they came up again?

The easiest way to sort out the information relating to major risks is in a simple table format, as shown in Table 2.1 opposite.

Any major assumptions or dependencies the project has should also be listed at this early stage. If your exhibition relies on loaned objects, for example, then this will be a risk until the loan agreements are signed.

Table 2.1 *Major risks summary table*

Risk	Mitigation	Effect on time, quality or cost
Marketing campaign doesn't reach intended audience, so objective of attracting X families is not met	Work with local schools to distribute information about the exhibition before they break up for summer	Need budget to produce leaflets and distribute to local schools; estimated at £NN.

Setting up the programme

One of cornerstones of project management is managing the programme. Putting together a project programme may sound daunting if you haven't done this before, but once you master the basic principles it will become easier. All exhibitions tend to have the same sorts of milestones and tasks that need to be completed, whatever the content, and so you will become familiar with what needs to go into the programme once you have completed the management of just a few exhibitions.

At the definition stage you outlined some of the key dates to go into the exhibition proposal. Now you will start to flesh this out into a fuller, more detailed programme of work. All the way through the project you will add detail and adjust the programme. No one writes a programme or timetable at the start of their project and never touches it again; things will change, new tasks will need to be added, people will take holidays and dates will need to be adjusted. This is fine so long as you know what is movable and what is fixed. Your opening date, for example, is unlikely to change.

The basis of an exhibition programme or timeline

Starting to plan an exhibition programme can be daunting. There are many elements that need to go into the project plan and a good way to start is by plotting out each stage of the project using the five stages outlined in this book. Remember that each stage will end with a gateway moment. I have laid out a suggested template (Table 2.2 on the next page) as a starting point for considering the sorts of inputs and outputs that are required to ensure that the development of the exhibition moves along in a timely manner.

For this example, I have focused on design work, but you should complete a note like this for each element of the project and ensure that all the outputs to be created appear as deadlines on the project plan and are assigned to individuals in the RACI (see below).

So, what happens during the design work?

Table 2.2 *Inputs and outputs for design elements of a project*

Project stage	Planning	Execute		
	Concept	Scheme	Detailed	Implementation
From you as client, at the start of the stage	Project brief Outline object list Draft interpretation plan Drawings of the space and any details of showcases	More refined object list with details of sizes etc. Start of the briefs for any interactive elements (AV, models etc.) Text hierarchy and key messages	Final object list with full information Briefs for any AV, sound, models or interactive elements Draft or sample text Feedback on details like materials, fonts etc.	Sign-off of workshop drawings, final text and images/film Prompt turnaround of workshop drawings Any items issued to the contractor (i.e. any sound or light equipment you have in stock or have bought directly for them to install) Final arrangement for delivery and installation of objects
To you from design team/ contractor, near the end of the stage	Concept designs and ideas	Scheme designs package, along with samples of suggested materials	Detailed design package including any material samples	Workshop drawings
Tasks you need to complete before moving on to next stage	Cost estimate Formal feedback on any changes required Sign-off of concept design by senior stakeholders (as part of project execution plan)	Cost estimate Any prototypes or samples Formal feedback on any changes required Sign-off of scheme design	Cost estimate and any value engineering required Final sign-off of designs Any permissions that may be needed, such as listed building consent or planning permission	Sign-off of the completed build, including completion of any snagging/ agreements when this plan will be completed

During the project there will be three stages of design: concept, scheme and detailed (for more on these see Chapters 4 and 5). Like most work in the project, design will cross more than one stage, with concept design falling into the Planning stage and scheme and detailed design coming in the Execute stage. When planning out a programme, start by dividing up the work into more manageable blocks or tasks. As you progress with the project you will find that you can add more tasks with specific deadlines into the programme.

For the design work the first thing you will need to do is recruit a team. Will this be in house or out of house? How long will it take to get them together and brief them? Will you need to go out to tender for the designers? Make sure that you assign enough time for this process and, if you can, break down the tender into stages and put a timescale to each one.

Once your team is set up you will start with the concept design. You will need to consider what you and the team, as the client (the person instructing the work), need to supply to the design team to start them off on their work. You will have already started to prepare some of this as part of the vision, set-up and interpretation plan, but you should still list any outputs as tasks with a completion date for delivering this information to the design team. You will need to record what you expect to receive back from the design team – and when you get it back you will need to feed back clearly any required amendments and then sign off the finalised work. This will be a part of the information that you put together for the gateway between the Planning and the Execute stages of the project.

Table 2.2 outlines the main elements that will need to go back and forth between the internal team and the designers at each stage of the project. You can use this as a basis for the programme and to start drilling down into and thinking about all the tasks that come under these headings and that will need to be completed before you can move forward.

This is a very high-level description of the programme, and there will be many tasks within it that will need to be completed. The more that you can list and fit into the programme, in the right place, the better your programme will be.

Defining the critical path

One of the most important things in putting the programme together will be to find what is called the 'critical path'. This is the series of tasks that must happen in order for you to achieve completion of the exhibition. This may sound daunting, but we use critical paths every day without really even thinking about it. For example, when you cook dinner in the evening your plan may be to take pie out of the freezer and defrost it, turn on the oven, chop and prepare vegetables, cook all the ingredients and set the table. All these tasks are necessary for completing the preparation of the meal, but some can't be done without the previous one being completed and some can be done simultaneously if you have the people (resources in PM-speak) available to do them. For example, you can set the table while the food is cooking, or someone else can do this task at any point (it is dependent mainly on resources), but you can't cook the vegetables without first preparing and

chopping them – they form part of the critical path, the tasks that must be completed before the next tasks can be performed.

Look at the tasks and see which are dependent on the completion of others. You can do this exercise alone, but I find that it works better if you involve the project team, because if they help to create the programme they will be more likely to be invested in making sure that it works. We will break down the process of finding the critical path into three stages.

Identifying dependent tasks

I find that the best way to start is with a sheet of paper and some Post-It notes. First make a list of all the tasks you can think of that will go into the making of the exhibition. You may want to include some of the following:

- Draw up an exhibition briefing document for designers.
- Complete concept design.
- Write implementation or project execution plan.
- Appoint 2D and 3D designers.
- Agree final object list (and arrange loans).
- Complete scheme design.
- Apply for any consents that may be needed (listed building, building regulations, planning permission).
- Complete detailed design.
- Prepare tender documents, including health and safety plan if needed.
- Tender for showcase manufacture and installation.
- Tender for the exhibition build works.
- Construct any set works and cases off site.
- Carry out any enabling works (new electrics, lighting tracks, repainting rooms etc.)
- Install set works, AV, lighting and sound.
- Install showcases.
- Install labels.
- Install objects.
- Focus lighting.
- Train staff.
- Hold opening event/press day.
- Open exhibition.

If you are responsible for overseeing these, you may also need to add:

- Website text.
- Catalogue / publications text preparation.
- Marketing materials.
- Wider signage across the museum.
- Updating any leaflets.
- Producing educational material.

There will probably be a fairly long list of tasks, but don't let this overwhelm you. Now you need to start putting them in order. For example, to be able to start installing the exhibition you will need get the text written and set into the graphic design. There are a number of tasks here that are dependent on each other (Figure 2.2). You cannot set the text until it has been researched, written and edited, so for the text production there are a series of tasks that must be completed in linear order and cannot be done simultaneously. Set out these dependencies as groups of Post-It notes (don't worry about the timescales just now) (Figure 2.3 on the next page). Like the example of text production, another subset of tasks would be showcase manufacturing and installation. This might look like: prepare tender documents, tender for and appoint a showcase manufacturer, construct off site, install showcases.

Figure 2.2 *Creating a group of tasks*

Placing blocks of tasks in order

Now that you can see blocks of tasks that are dependent on each other, consider the order in which these blocks can be done. For example you may have a block of tasks related to getting objects ready for display. Beginning with creating a long-list of objects, this will move through refining the list,

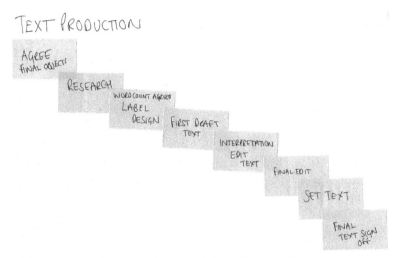

Figure 2.3 *Arranging tasks in the order in which they will be completed*

agreeing loans and producing the final object list. Now you will see that you cannot start writing text until you have the final object list, so not only are tasks within a block of tasks dependent on each other, but there are also dependencies between blocks of tasks. Some task blocks may start part way through a preceding block; others may not have any links at all to other task blocks. Consider what would be the best sequence for completing tasks or blocks of tasks, and arrange them in order.

Adding a timescale

Once you have all the tasks placed in blocks and in the order in which they need to happen, you can start to add in the times that you think they will take. You will find at this point that the things that constrain you are those tasks that take the longest time to complete, and this is how you will define the critical path. For example, if text preparation will take 12 weeks to complete, but installing the showcases will take 14 weeks, then the showcases will be the constraint on finishing that segment of work. There will be mini critical paths in every block of work, but what you need to find is the tasks that overall take the longest and must be completed before you can finish.

Sometimes you can speed up the critical path by adding more people into the equation. For example, in the critical path for making dinner you could speed things up by getting someone else to prepare the potatoes while you prepared the vegetables. Consider who is doing what and when, and whether you have enough people and budget to speed things up in this way.

Gateways

Now that you have set out all your tasks with their timescales you will need to consider where the gateways are. Gateways are moments in a project when the activity shifts from one type to another, and you are required to present pre-agreed information for sign-off from senior management or stakeholders in order to progress. Remember as outlined above a gateway is also a milestone (a moment in a project which doesn't have time allocated to it) but not all milestones are gateways. Examples of milestones for your project might be the sign off of text – this isn't usually something that requires the full sign off by your full project board or senior management so although it needs marking down on your project plan as a milestone, it isn't also a gateway. You will have a number of milestones in your project but if you follow this project management framework you will make only five of those milestones into gateways in your project plan: definition, planning, execution, transition, evaluation. You could choose to use another project management framework such as PRINCE2 or the RIBA Plan of Work (see Chapter 5 for how the RIBA stages map this book's template); for both of these you will see that they also have clear gateways moments. You may need to set your gateways around the museum trustees' meetings, for example, or your meetings with the project board or senior management team to show them progress. Note on the programme which stage you are moving from and to. Highlight them so that the whole team knows the deadlines to which they are working for each stage of the exhibition. This can really help with motivation and it will help you in organising the team's time.

Once tasks are mapped out with their timescales, the resources (people) to carry them out have been identified and the gateways have been set, you can transfer the information into a more formal format. There are plenty of software packages to help you create a project timeline or programme. Microsoft Project is a favourite with many PMs, but it's not very intuitive to use and, being something of a specialist package, it can be difficult to share with a team. You can create a simple programme on a spreadsheet, or you can use one of the many other software options, including Monday.com, Trello or ProjectManager.com, or you can simply write the dates on a wall chart or whiteboard. However, the more complex the project, the more sophisticated your tool for measuring progress and setting up a project plan will need to be. You must be able to see at a glance what is due when, what is dependent on other tasks and what your critical path is. Without this, if, for whatever reason, something is going to be late, you will not be able to work out what effect it will have on the programme as a whole.

Roles and responsibilities

Now is the time to confirm the structure of the project. Who is the PM and who has the authority to sign off the project work? Usually the person signing off the project at an overarching high level is a different person from the PM and is known as the project owner. You need to work out where the authority sits to approve expenditure or to sign off designs. For designs, it could be the project owner, or the interpretation manager, or the PM. Whoever it is, make sure that this is clear. Who will the PM be? Will it be you? Who will approve purchases – your superiors? Who will sign off the contract to build the exhibition – a specially convened project board, your trustees, the project owner, or you?

The project team

Identifying the project team and those with responsibility for the project will mean that you can introduce people to the project with a clear plan of what they will be doing and what they will be responsible for. This will really help the team to hit the ground running and get straight into working on the project.

Who will be part of the project team? Who needs to know about the project? Who will do what? And how will you all work together? Often with a new or exciting project more people want to be involved than there are roles for. This is where being clear about the work to be done and who will be making decisions will really help you to keep a focused team. There are a series of tasks that can help you in defining these details: identify each role needed to fulfil the project and write a brief description of what they do and what they are responsible for, then create a RACI document which sets out who is responsible, accountable, consulted or informed for each project task – see below for more details on how to carry out these tasks. By the time you reach the stage of putting together the project brief it is likely that some of the project team will already be working with you and you will know what their roles are, so this part may be quite straightforward. But remember to keep thinking about your definition of the project, and make sure that you assign the right people to deliver this. For example, will there be an associated schools programme and, if so, who will be working on it? Who is the curator, scientist or researcher? Who will edit text? Who will be sourcing images? Who will set up contracts for specialists such as mount makers etc.? Many things may be outsourced, so who has the authority to instruct external specialists? You can easily lose control of costs and introduce confusion if this is not agreed and watched closely by you, the PM. This stage of organising the team is a key element of the project and is overlooked at your peril. Any instruction

to consultants or contractors is likely to come with an associated cost, so all lines of communication need to be crystal clear.

Now is the time to consider the make-up of your team. You have already started to think about how to expand the audience. Does the team reflect the audience or users? Is it a diverse team that will produce an inclusive end product? Museums across the world are thinking more deeply about their inclusive practice and how they can become more representative by questioning traditional narratives and bringing in new voices. How will the team contribute to this, and how is this reflected in your exhibition definition and the museum's vision? If the team doesn't reflect the target audience you may want to consider recruiting an external advisory panel or working with existing community groups that can provide you with advice and guidance on content and audiences.

Team roles

Set aside time now to think about who you want on the project team, what role they will play and their main responsibilities. In smaller museums a single person will take on many roles, but it's worth understanding what the roles are and the amount of effort that has to go into creating a new display or exhibition. Quite often, especially in smaller institutions, one person may take on too many responsibilities. Look at the tasks and roles critically and ask yourself whether they really need to be done by you or by that one person, or whether they can be delegated? Can a volunteer help? Will you need external help to fill any of the roles?

Curator. Almost all exhibitions need a curator or a scientist, historian, researcher or subject specialist. We will call this person the curator. The curator is responsible for the object selection, and in many cases for the narrative as well. They will have been involved before the project became a project and may feel hesitant about letting control of the project go over to the PM. You will need to be clear about your role, which is not that of a creative but that of an enabler who will support and guide the team to realise the vision.

Interpretation specialist. Depending on the size of the museum, the narrative work will sometimes be the responsibility of an interpretation specialist. This person works with the curator and they take on the role of audience champion. They develop the scholarly narrative into an exhibition-ready storyline, narrative or set of concepts that are pitched to the needs of the audience. They will also draw up the interpretation plan, developing the text hierarchy and choosing the right methods for imparting information

to the audience, including additional resources to make the exhibition inclusive, such as large print guides or tactile objects. Sometimes you will need to be a facilitator between the interpretation manager and the curator, as balancing of audience needs and in-depth scholarly research can be a fraught process. Having a clear vision and objectives can take the heat out of discussions and focus the team on outcomes already agreed.

Project manager. The PM is responsible for the timely delivery of the project, to budget and to the quality described in the project vision. Often the PM will also have another role in the project, but it is good to identify them as the PM as they usually have decision-making power over the use of the budget and will need to hold everyone to account to deliver their elements of the work on time, to the quality expected and in support of the exhibition objectives. The PM holds the vision and ensures that the project doesn't go off on a tangent or suffer from scope creep. The PM will also act as the link between the project team and the senior decision makers.

Designers (2D and 3D). More often than not the designer of an exhibition is external to the museum. Only the largest museums have in-house design teams, and even those that do often bring in external designers for their big exhibitions. There are two types of designers: 2D specialists in graphics and 3D designers who work on sets and layouts. Depending on the project, you will probably need other specialists such as lighting, sound and/or AV designers. Often these can be subcontracted by the 3D design team if they don't have these specialisms themselves.

In my experience, the best exhibition projects have a neat triangle of decision-making powers between the curator, the person doing the interpretation work and the designers, with all their activities being monitored, kept in balance and directed by the PM (Figure 2.4). If everyone works in partnership and collaborates, this is where the creative magic happens! Get it right, and you

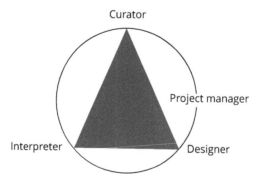

Figure 2.4 *The balance of roles on an exhibition project*

can create an exhibition that is founded in sound research and scholarship, considers and meets the needs of the audience, is accessible and is designed in a way that is creative, fun and innovative and, importantly to you as the PM, is delivered on time, on budget and to a high quality that fulfils its objectives.

Supporting this golden triangle/circle combination are a host of other team members, all carrying out essential work. They can include the following:

A defined project owner/champion. This is usually a member of the senior management of the museum who is championing the project. The PM will report progress to them and escalate to them any problems they can't solve by themselves or with their team members. They will also help to provide solutions to problems that arise during the project. They are usually the budget holder.

Conservator. The conservator is responsible for the protection and preservation of objects. Conservation specialists will carry out any treatment work to make objects ready for display, including carrying out condition checks and looking after loaned objects as they arrive. Once the objects are on display, they will use their preservation skills to ensure that the objects remain in good condition. You may have someone or even a small team from a conservation department working on the project, advising on the suitability of objects for displays; carrying out specialist conservation work on objects; liaising with lenders on condition reports and object packing and transport; providing information to the designers and fabricator about the use of materials and the display conditions the objects require, such as showcase specifications or special mounts. They may also help you to work out timescales for the preparation, installation and mounting of objects. You may need to buy in some of this help if you don't have it in house, depending on the number of precious objects to be displayed and their condition.

Registrar. If the exhibition is likely to have many loaned objects there may be a registrar on your team. They are responsible for arranging the legal side of object loans, including transport, insurance and lender liaison. This work is sometimes carried out by the curator, but in larger museums or galleries this is likely to be a separate function.

Front of house. This is the operational side of the museum, responsible for visitor services. Sometimes this team is left out of exhibition project teams but their wealth of knowledge regarding visitors and how well exhibition elements work on a day-to-day basis, means leaving them out is a risk. They are an audience advocate and provide information about visitors' behaviour and interests. They are responsible for ensuring that the

exhibition is practical and easily maintainable and meets the needs of staff and visitors.

Other functions that you need to cover will include health and safety, and security. There may be others, such as marketing and press, learning and publications and specialist access advice, depending on your museum's set-up and the scale and type of the exhibition.

For each member of the project team it is a good idea to write a short role description. This need be only a few sentences, but it should set out the parameters of their role on the project. For example:

Curator

Responsible for:

- exhibition narrative (in collaboration with audience advocate/interpretation manager);
- exhibition object list and loan negotiations;
- first draft exhibition text (working to parameters set by interpretation specialists/designers on narrative focus, word count and text hierarchy);
- completed publication text.

RACI

Once you have considered the roles needed on your project team, it is time to record the level of responsibility and decision making each will have. Even if the project team is very small it is a good idea to list this out. At this stage this will just be a very brief outline of what each person will be responsible for, but if you have a more complicated structure with a board to report to or other stakeholders you may want to consider using a RACI system. This is where you identify who is Responsible, Accountable, Consulted and Informed. This is a useful document because it will help you if things become difficult and decisions are questioned.

Responsible. This is the person who is doing the work. For example, a designer may be responsible for producing a colour scheme for the exhibition. They may produce a few different options and have a preference as to which one should be chosen. You should define the tasks so that it is very clear who is responsible for producing what. You can have more than one person responsible for tasks; but, if this is the case, in your RACI make sure that each person knows exactly what they are producing and how this fits in with others who are also responsible. For example, both a curator and an interpretation specialist may be responsible for

producing exhibition text, but they need to know and agree between them who will be producing the first draft, who will have the last say on the text (who will be accountable at that moment) and who is to deliver what information and when.

Accountable. This person has the power of decision making or approval. They are the person who will make the decision about which colour scheme will be used and who will sign off the final text. There should be only one accountable person. Having more than one accountable person will lead to confusion. You need a clear decision maker in case of any disagreements.

Consulted. These are people whose opinions are sought. They will be asked which colour scheme they think works best. They may also provide input into the work, making suggestions to the person responsible, but they don't have the authority to make the final decision and they don't have responsibility for creating the choices. The views of those who are consulted are often very powerful – this is not a minor role. But it is important to note that even if their views are strong, they aren't the ones to decide. Only the accountable person can do that.

Informed. These are the people who are told what the decision is after it has been made.

The accountable person will often change, depending on what stage the project is at. For example, the museum director may be the accountable one when it comes to setting the budget for the exhibition, but they may only be consulted on the designs.

Apply tasks to a role in the process, rather than to a job title, and assign each role to an individual. Understanding your role and what decision-making power you have is very important; if this is not clearly outlined at the start it can lead to confusion, cause delays in decision making and even add to cost. If you assign tasks to roles outlined in the team structure, rather than to named individuals, the RACI can become a template that you reuse again and again. It can be invaluable if any of your staff change during the project, as there will be a clearly defined role for the new person to pick up.

Try to describe the activities and decisions as succinctly as possible and make them specific. At this early stage of the project you won't know all the decisions and work that will be needed. This is acceptable; you can write down what you know now and make sure that the lines of accountability and responsibility are outlined in draft. Like the rest of your plan, the RACI should be a live, working document that you will return to continually throughout the project to refine, add to and consult. Be careful, however, to avoid changing specific tasks, but only to add in new ones. It can cause

confusion and start unhelpful debates if you start changing the reporting and sign-off routes partway through the project.

Creating the RACI matrix

To create the RACI matrix, list the roles along the top, remembering that they are unlikely to match up to people's job titles and some people may cover more than one role. Then list the activities and decisions that will be needed down the side. For each of the activities and decisions mark the appropriate letter R, A, C or I under each role (Figure 2.5).

RACI
―――――New Exhibition―――――

	Project Owner	Project Manager	Curator	Interp Manager	Designer	Marketing Manager	Front-of-House Rep
Sign off expenditure	A	R	I	C	C	I	I
Sign off final text	C	I	R	A	R	I	C
Sign off concept	A	R	C	C	R	C	C

R = Responsible
A = Accountable
C = Consulted
I = Informed

Figure 2.5 *Example RACI document*

Start by mapping out the RACI for project gateways, then add in key tasks such as choosing the creative designer (if you are to have an external one), defining who is accountable for the final object list, who signs off the budget and designs. As you develop the project programme and activity plan you can return to the RACI and add more detail. What is key at this point, however, is defining which kinds of decisions will be taken by more senior management, which can be taken by members of the project team and who, among the team members, takes on that accountability. You are really

thinking about the governance of the project and ensuring that lines of communication and authority are clearly laid out.

Common problems you may face in drawing up the RACI include the following:

- **Not knowing who is accountable for decisions**. Sometimes it can be hard to know who should be accountable for a particular decision. One way to figure this out is to think about who 'owns' this work, who will sign it off as complete. If there is a conflict you will need to talk to the people involved and try to resolve it. One of the most common problems in projects is not having a clear understanding of when and how decisions are made.
- **Too many people being responsible.** If too many people are responsible for a task it is unlikely to get done. No one will know who should be doing the work, or it will take too long because it is being done by committee. People often like to work collaboratively, but it is best to limit the number of people who are responsible for getting it done to just one or, if really necessary, two, otherwise it may result in confusion. As PM you need to be able to judge who on your team will be the best fit for being responsible for the delivery of these tasks and slot them into these roles. You won't always get it right. No team is made up of people who work with 100% dedication for 100% of the time, and different staff will have different strengths. If something isn't working, you need to review things and reassign roles if necessary.
- **Filling the boxes**. You don't need to fill every box in the RACI; in fact, this is a moment to be selective. Consider carefully whether everyone really needs to be consulted. Can they just be informed – and do they even need to be informed about everything? Consider what value they will bring by being consulted and whether you are consulting them simply because you feel you ought to, or because they may be difficult if you don't. What is the risk of not consulting them?
- **People aren't aware of the roles you have assigned to them.** Share the RACI with everyone you will be working with, and work through any worries they have about where you have placed them. Make sure that everyone has seen the RACI and is signed up to it; or at least, accepts the role you have given them. When starting tasks, remind people of their roles; and don't be afraid to bring out the RACI and discuss it with individuals if they stray into an area for which they're not responsible or accountable, or if they're not stepping up to the tasks they were assigned. Do they know they are responsible? Did you discuss their roles with them and were they prepared for what that meant? Perhaps they can't

manage what you have assigned, or they are worried about taking on the role. What can you do to support them?

The RACI is not a substitute for discussing progress with your project team; nor is it wise to trust that because you have discussed people's roles with them you can now leave things to run as they are set out on paper. As PM you need to follow up on tasks, help to sort out problems, support those accountable in their decision making, communicate what is required clearly and often and be there to encourage and lead the team.

Decision register

Alongside the RACI it is also a good idea to set up a decision register. At its most basic this should be a table which records when the gateway moments of the project are passed, who approved them and some evidence to show that the decision maker really did make the decision. On more complex projects you can use the RACI to identify who is making decisions about what and to match this up to the project programme, recording each time a decision is made, who made it and some evidence (an e-mail, a record of a phone call, meeting notes) to show that this was agreed. This helps to stop team members from questioning decisions and provides some clarity on what was decided, when. If someone asks a question, or even questions a decision, you can quickly refer them to the evidence and often avert what could be a protracted discussion about something that has already been agreed.

Table 2.3 *Example decision register*

Decision	Decision maker	Date of decision	Evidence
Approval of concept design	Project board	20/9/2023	Notes from project board meeting saved at xxx (or a hyperlink)

The communication plan

Another key document in your project set-up is the communication plan. You need to establish a common understanding within the team and among the key stakeholders as to how you will communicate. How will decisions be disseminated? In what forum will people be consulted? How will those responsible pass on the tasks they have completed?

Identifying stakeholders

Start by doing some stakeholder analysis, as you may find there are people inside and outside the museum who will need to be consulted or even who have decision powers that are outside the core project team. How will you communicate with them and bring them with you on the journey of the exhibition implementation? Do a quick exercise to identify and list key stakeholders. List all those who have an interest in the project, who aren't directly involved but who could influence its outcome. For exhibitions these are likely to be the museum's trustees, key lenders, perhaps the family or estate of a figure whom you are going to feature, funders or sponsors of the exhibition and any partner organisations such as community groups (these are especially important to ensuring that the exhibition represents the audience) or friends of the museum.

Now you have a list of key stakeholders, use this to help create a communication plan. It will have three sections:

1 internal communication;
2 communication with external stakeholders;
3 communication which promotes your exhibition (this section may be the responsibility of the press and marketing department if the museum has one).

Consider each of these in turn and establish what needs to go into them.

Internal communication

Here you will identify all those team members who need to be able to communicate with each other, decision makers and any internal stakeholders who need to be kept informed. List out how you will communicate with each of these people. For the core project team this will likely be weekly or fortnightly meetings plus e-mails, and perhaps an online group on Teams or Trello where you log and monitor actions.

For decision makers there will be the formal sign off meetings for your project gateways. This could be a monthly board meeting or a specially convened group that meets according to your programme.

It is important to agree with the team at the start of the project how and when you will communicate and meet, and to monitor this as you go along. This ensures that the right people have the time they need between meetings and the communication lines to other team members to carry out their roles on the RACI.

Internal stakeholders could be the museum's trustees, or the front-of-house staff, or the catering staff. Think about how you will communicate with them. Can you or the curator attend front-of-house staff meetings to give updates or a talk? How can you use internal newsletters or notice boards? Will you present the project progress to the trustees at defined stages, or will you need to brief the director about this?

External stakeholders

By thinking about the exhibition and the museum you will easily come up with a list of external stakeholders. These may include funders and donors as well as lenders; perhaps local councillors; and neighbours of the museum such as local business or residents' groups. Each museum will have contacts and supporters that it will need to keep informed about developments. If the exhibition is likely to attract crowds or change the way that people visit the area, there may also be detractors who need to be won over. These external stakeholders may need careful management, and so it is important for you and the team to establish who will contact whom, and how and when this will be done.

One way to help you decide when and by whom external stakeholders should be communicated with is to do an analysis of their influence and importance to the project and the museum. Take each stakeholder and plot them on a chart showing their level of influence (high to low) and their level of importance to the museum (again, high to low). You will then see who it is most important to maintain contact with, and you can assign the right level of contact with them.

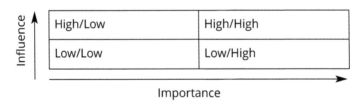

Figure 2.6 *Stakeholder influence/importance matrix*

Promotion

The promotional communication of your exhibition will be a plan in itself, but should form part of the overall communication strategy. For example, you will not want to brief a local councillor about the exciting plans you have for the museum if you have not yet agreed how you will be talking about it to the press. Consider when you will start talking about the exhibition externally and how this will influence discussions with some of your key external stakeholders.

You will also need to consider what storyline to convey through the release of information on social media and on the museum's website, and how this will tie into any marketing and other press activity. This work is often done by a specialist, but if you are working in a small museum, include it in the communication plan. If your museum has a social media and web specialist, be sure to liaise with them and to insert the key dates and outline of their work plan into your programme and overall communication plan.

If the museum has a press or marketing team, make sure that you describe the project and 'sell' it to them. If you cannot enthuse the team who will be promoting it, how will they be able to create material that will encourage an external audience to spend their time and money to come? This team will also need some of the project team members to create content, such as website entries, blogs or even publications. If this is the case then you need to build in time to the programme so that curators, for example, aren't pressurised to produce book text and exhibition text at the same time.

Writing the plan

I find that the easiest way to write a communication plan is to use a spreadsheet and create a tab for each section of the plan, listing each contact or group of contacts and identifying how they will be communicated with and who will be the lead contact or chair of a meeting or group if this is appropriate. You will also want to list how often the communication is to take place. Table 2.4 shows one of each type of stakeholder, but if you are creating a complete plan I recommend creating a separate table or tab for each stakeholder type.

Table 2.4 *Example communication plan*

Type of stakeholder	Stakeholder	Method of communication	Frequency	Responsibility
Internal	Project team	Meetings E-mail	Weekly As required	PM Team members (copying in PM)
External	Local MP (high / high)	Letter	At start of project to inform Invite for tour as build takes place As guest of honour at opening event	Museum director Event manager via museum director
Promotion	Twitter followers	Tweets (monthly content plan to follow)	Once a month from announcement	Social media manager

Sustainability

In today's world no project should be embarked upon without considering its impact on the environment and looking closely at how it can be made as sustainable as possible. As you define the project this element should be high on your priority list and should be considered at each stage. When you start putting together your project fundamentals is a good time to start considering how much time, money and effort to commit to making the project as sustainable as possible.

By their nature, temporary exhibitions can be wasteful. Although you are creating a physical experience that will be in place for a relatively short time – perhaps only a matter of weeks – this doesn't have to mean that it is guaranteed to become landfill. There are many ways that you can recycle, reuse and change materials and design to avoid this. At the start of the project, make clear to your team and designers the importance of sustainable practice, and start investigating and questioning material choices and build methods to see how you can lessen the environmental impact of the project. Every aspect should be considered, from the choice of lighting to the ink used to print leaflets, as well as the big stuff such as sourcing the showcases and how the objects will be transported.

Keep a sustainability register, and make it as broad as possible. Sustainability is not just about carbon reduction, but can also be about sustaining communities, improving people's well-being and forming lasting partnerships. It can be helpful to start by looking at your local council's sustainability goals. What are the targets for your area, and how can you contribute to them? Do you know the difference between carbon neutral and carbon net zero, and which might it be appropriate for you to aim for? Have a look at industry standards. In the UK, the Museums Association has information on its website about how museums are tackling climate change. For theatres, there is the Theatre Green Book (see Online resources), which has many transferable tips on how to create a more sustainable show. You may want to broaden out your reach on sustainability beyond the physical build of the exhibition, perhaps thinking about the sustainability of your messaging or the effects it will have on visitors, such as well-being or building stronger community links.

Agree on your goals as part of the planning process, track them and add to them as you progress through the project.

Gateway moment

The output from your work of setting up the project will be combined with the interpretation plan (see Chapter 3) and the work you do with the designers in the concept design phase (see Chapter 4) into a project execution plan (PEP) for approval by the project board or senior management team. The creation of the PEP will be a significant gateway moment for the project, following which the project will move from the planning to the execution stage. At this moment you will be asking: 'Have we planned this exhibition as you, the museum, expect and is it the style of exhibition you want to see? Are you happy for us to continue and start spending more money on making it a reality?' If the answer is 'yes' you will now move to the execution stage of the project.

Let's summarise

In this chapter we have completed the initial planning phase by:

- assigning a high-level budget to the project;
- recording the major risks and starting to think about how you might mitigate them;
- creating a project programme;
- setting up the project team and assigning roles and decision-making powers;
- setting up a communication plan;
- thinking through how to make the project sustainable.

CHAPTER 3

Interpretation Planning

Introduction

Some museums are lucky enough to have an interpretation department. There are many great books available on what interpretation is, and which provide excellent frameworks for interpreting collections (we will discuss some of this below, and see the further reading list at the end of the chapter). But many smaller museums don't have a dedicated interpretation specialist, and because I believe that the creation of a robust interpretation plan – referring back to and reinforcing the museum's values and mission – is a key part of the success of a well-managed exhibition process, this chapter will outline what you might consider adding to your plan and how it will help to make the exhibition a success. Creating a well thought-through and clear interpretation plan is a key part of the planning stage of any exhibition.

What is interpretation?

There are many different definitions of interpretation. Simply put, it is about the tools that are used to bring objects and stories to life and to provide visitors with ways to explore and create emotional connections to content. This can be through traditional means such as well-written labels or leaflets, or through much more experimental forms such as ghostly projections of patterns onto plain white 18th-century silhouettes! As so many things can be 'interpretation', it is hard to pin down – and even harder to know if you have got it right.

Let's go back to the beginning. In 1957 Freeman Tilden described interpretation as 'An educational activity which aims to reveal meaning and relationships through the use of original objects, by first-hand experience and by illustrative media rather than simply to communicate factual information' (Black, 2005, 179). Freeman Tilden is considered to be the first modern writer on the subject of interpretation, and his first book, *Interpreting Our Heritage*, is still used today by museum and heritage professionals. Tilden was based

in the USA and worked for the National Parks Service, who were trailblazers in the world of interpretation. He set out six principles for interpretation, which work as well today as they did when first published and are still often used as a basis by writers and interpretation professionals. Tilden's six principles are:

1. Any interpretation that does not somehow relate what is being displayed or described to something within the personality or experience of the visitor will be sterile.
2. Information, as such, is not interpretation. Interpretation is revelation based upon information. But they are entirely different things. However, all interpretation includes information.
3. Interpretation is an art, which combines many arts, whether the materials presented are scientific, historical or architectural. Any art is in some degree teachable.
4. The chief aim of interpretation is not instruction, but provocation.
5. Interpretation should aim to present a whole rather than a part and must address itself to the whole man rather than any phase.
6. Interpretation addressed to children (say up to the age of 12) should not be a dilution of the presentation to adults but should follow a fundamentally different approach. To be at its best it will require a separate programme.

<div align="right">(Tilden, 1957, 9)</div>

Graham Black quotes Tilden extensively in his seminal work, *The Engaging Museum* (2005), and more recently Steve Slack has adapted the six principles in his work on *Interpreting Heritage* (2021). Breaking this down further, both Black and Slack are using a simple set of questions to organise and define how to display information alongside the collection. These questions are a variation on:

Why do you wish to develop/change the presentation, what is your interpretive purpose?
What do you wish to present and what do you want to happen as a result?
Who are you targeting the presentation at; or, more simply, who is it for?
How do you intend to present these ideas; or what are the interpretive devices you will use?

<div align="right">(Adapted from Black, 2005, 185 and Slack, 2021, 38)</div>

Looking at this hierarchy I would argue that the Why, What and Who of your interpretation plan come at the earliest stage of planning and are part of your

definition. This is the element of interpretation that will act as the foundation for the exhibition and should be agreed on as early as possible in the process – remembering that it should always refer back to your vision and the museum's overall organisational mission. This should be the 'DNA' which runs through everything you do on the project.

That isn't to say this is the only methodology you can use. Lisa Brochu's 5-M model (2003) is another useful way of planning the interpretative strategy, but it goes slightly wider than the single exhibition and encourages holistic thinking about the five Ms listed in Table 3.1.

Table 3.1 *Lisa Brochu's 5-M model* (Brochu, 2003, 4–5)

Management: the nuts and bolts associated with running the interpretive operation. Includes mission, goals, policies, issues and operational resources such as budget, staffing and maintenance.
Message: the ideas that will be communicated to the visiting public. Includes theme, sub-theme and storylines based on resource, audience and management considerations.
Market: the users and supporters, both current and those who may have an interest in the subject or site in the future; and the implications of targeted market segments and market position.
Mechanics: the large- and small-scale physical properties that have some effect or influence on what is being planned.
Media: the most effective method(s), given the mechanics of the situation, for communicating messages to targeted market segments in support of management objectives.

As Wells, Butler and Koke (2013, 4–17) argue in their book, *Interpretive Planning for Museums,* all too often exhibitions are developed without considering the needs of the visitors. By putting a systematic process in place for planning, this critical element can be built in for the benefit of both the museum and its users.

What is clear from reading through all these models is that underlying them is the same intent: to encourage visitors to think, make meaning and establish connections with and from your displays, rather than just to absorb facts. Interpretation is about making the museum a space that is relevant to people and communicates and connects with them. Or, as the UK's Association for Heritage Interpretation puts it, 'interpretation enriches our lives through engaging emotions, enhancing experiences and deepening understanding of places, people, events and objects from the past and present', and is 'the art of helping people explore and appreciate our world'.

Key to interpretation is that it is focused on the audience and provides the sort of environment that people want to spend time in, even if the subject matter is challenging. Interpretation should extend beyond the exhibition rooms and encompass the tone of the museum as a whole, establishing it as

a place that is inclusive and welcoming. Understanding the audience and their reaction and response to the content and objects is the first main step in creating an interpretation plan. As Blockley and Hems point out, though, 'Professional interpreters also lack a coherent framework within which to deal with the ideas and assumptions of audiences and visitors who bring with them their own notions of the past, their own values and their own sense of place. Thus we still talk about "bringing the past to life" when what we are really doing is trying to engage our visitors in the present' (Blockley and Hems, 2006, 2).

As indicated above, you will see that there is a wealth of books on interpretation. If you don't know much about the subject, I urge you to do some further reading, as one chapter in a book focused on the mechanics of delivering an exhibition isn't going to give you the knowledge you will need if you are the one charged with completing the exhibition interpretation plan. You can get started by turning to the reading list at the end of this chapter.

Getting the interpretation right is the key to an exhibition's success. If visitors don't connect with the subject matter, they won't visit; and if they do visit but aren't feeling a connection, they won't stay or provide you with that ever-so-valuable word-of-mouth recommendation.

Your role as PM is to make sure that the team are considering the audience and producing an interpretation plan for the exhibition. This needs to be done early in the process. A good interpretation plan is possible only if you have a clear vision for the exhibition, as the ideas will flow from this. Make sure to spend time on the definition, and remind the team to return to this when planning the interpretive hierarchy. Many interpretation plans start with the vision document and build on this foundation.

The curator should have a wealth of research to back up the exhibition idea, or if the exhibition idea wasn't the result of a research project, then time for this research to take place needs to be built into the definition stage of the exhibition. It is from this research that the interpretation plan starts to take shape. The plan will need to refine this wealth of information into a number of clearly defined elements or outcomes. As Black describes, the central point should be 'what are the primary messages required to reinforce the big idea?' (Black, 2005, 196). Beware of what Brochu and Merriman describe as 'interpreganda', where your interpretation provides only a one-dimensional view of the objects on display (Brochu and Merriman, 2002, 17). Visitors expect to hear different points of view. Consider, for instance the Black Lives Matter movement, founded in 2013, and the response to the killing of George Floyd in the USA in 2020 and how, resulting from that, museums reacted to make greater efforts to be more inclusive, to tell more diverse stories and to carry out fresh research, adapting their work to ensure inclusivity and relevance.

The interpretation plan

The interpretation plan will take time to produce, and this will need to be built into the project plan. It will be the output of a range of workshops and discussions and isn't something that can be created in a hurry or by a single person working alone. As Slack says, 'In its simplest form, an interpretation plan is a document. But it's also so much more than that. An interpretation plan is a process. It's a conversation, a collaboration, a journey, a hope, or aspiration, a manifesto' (Slack, 2021, 33). A large range of models are available to help you pull the plan together. Alongside the question-based approaches suggested by Black and Slack, you could also try out the TORE method developed by Sam Ham. Ham suggests arranging your information by **T**heme, using **O**rganisation to make those themes easy for the visitor to understand and process, **R**elevant to the audience so that they connect and **E**njoyable – after, all most visitors are on a day out that they have chosen as a way to spend their leisure time (Ham, 2013, 19–48). The big question to keep asking when trying to test the relevance of your themes or ideas is 'so what?' (see Serrell, 2015). Throughout my career working on exhibitions this has been one of the most useful questions for testing whether I have got across the heart of the information. The advice from Museums and Galleries Scotland provides a useful summary of the sort of information you need to think about when creating an interpretation plan (see Online resources). You will also find a useful template on the Wessex Museum website (see Online resources).

Connecting with the audience

Start planning the interpretation based on the outcomes you wish to achieve. Looking at what you want the visitors to take away from the exhibition is the starting point for planning and ensures that you will connect with the audience. The difficulty lies in measuring these outcomes and being inventive and open enough not to end up with nothing but a didactic list of learning objectives. Try giving equal weight to the emotional journey you want visitors to go on, and consider what social outcomes your work might produce, such as forging new links between communities or groups. If you aim to create some learning outcomes you could refer to the Generic Learning Outcomes produced by Arts Council England. Although these were produced some time ago, I still find them a useful starting point. For working in an outcomes-centric way without falling into the trap of creating something too didactic, *Interpretive Planning for Museums* by Marcella Wells, Barbara Butler and Judith Koke is helpful.

Another way to connect with your audience is through the tone of voice of the exhibition. This is a key decision, because once the audience is defined

you will need to agree on how to communicate with them. Does the museum have a house style that you will follow? Can you be flexible and break away from it, and, if so, what changes will you make? Will you write in the third person, with an authoritative tone, or perhaps use the first-person voice of your curators, the community and others? Will there be one voice or many? Will you write formally or informally (either way, the writing should be informed!). These are important questions that need to be agreed and documented as part of the plan.

Brochu (2003, 51) suggests that when putting together the interpretation plan you will need to gather information and analyse it; carry out option appraisals to define the narrative, themes, storylines, emotional journey etc.; select approaches for delivering information; and then make an action plan for how this will be delivered, keeping in mind that visitors need personal, social and physical contexts for understanding objects. This will need to be done in consultation with curators, audiences, front-of-house team members and as many other groups as you can engage with to create a plan for the exhibition that is truly visitor-centric. Falk and Dierking say that 'Visitors want to know what the museum values, yet often visitors leave museums without a clue' (Falk and Dierking, 2011, 131). So, consider what values your museum has and how these will be reflected in the exhibition. Revisit the museum's mission statement or vision, and take a look at its strategic plans. 'Exhibitions are the major media through which museums communicate with the public, so getting this right in your temporary shows is very important as it will set the tone of how the museum is perceived by its audience' (Falk and Dierking, 2011, 135). As Falk and Dierking go on to say, you will need to think about the experience that you want visitors to have, not just the information, stories or narratives you want to tell. This is absolutely imperative; meeting the museum's overall mission or vision through your project work is what it's all about, and nothing you create should be at odds with this.

Communicating to the audience

Once the interpretation plan has broken down the narrative, story or themes of the big idea and included ideas around sub-themes or alternative viewpoints, it needs to move on to the ways in which the information will be imparted to the visitor. Nobody comes to a museum to read a book or list of facts – they could do that on their phone or at home on the comfort of their own sofa! People come to museums and visit heritage sites to interact with real things and see different spaces, to have a day out and maybe share time with friends or family. Presenting all your stories, narratives or themes as written information doesn't provide for differing learning styles, it doesn't

allow for interaction between visitors, nor does it allow visitors to make connections through doing, participating, listening or watching. In a place where a tangible, real object is the focus, written interpretation alone doesn't give people the opportunity to use all their senses. Visitors want to be engaged and to connect with the content, and often they also want to participate. The interpretation plan should consider how this can happen and needs to detail how you will hold visitors' attention throughout the exhibition.

We have all been there and suffered 'museum fatigue'. When we are presented with case after case of similar objects with similar interpretation, our curiosity gets dulled, the effort to read the information and try to extract the relevant story is too hard, and we give up and go for tea instead. The job of the interpretation plan is to prevent this tailing-off of enthusiasm and curiosity and instead to feed it and allow it to grow. Good interpretation should provide ways in for those with very little knowledge of the subject, but without making them feel that they are being talked down to or alienating them by assuming knowledge that they don't have. At the same time, it also should cater for those who bring with them some subject knowledge and who are seeking deeper connections than they have been able to make through their own research. This is a difficult balancing act and it takes skill and experience to get it right. Visitors always try to understand objects through the lens of their own experiences, and you should encourage visitors to personalise their experience (Falk and Dierking, 2011, 139) and make their own meanings from what is displayed.

To cater for differing starting levels of knowledge and interest, you should layer information. What are the most important messages you want to get across? What are the secondary and the tertiary messages? By layering information, you can provide a way in for those with a wide range of starting knowledge and experience. But beware of the interpretation messages straying away from the objects. As Black points out 'The challenge is to both grab the visitor's attention, then to hold it by engaging the visitor directly with the content and then, as a result, encourage reflection' (Black, 2005, 196). Remember that 'so what?' question.

Aids to communication

For an object-based exhibition, consider how you will give context to the objects, which may be unfamiliar or visually unappealing, and may have come from long ago or far away. Do you need maps, images, a timeline, an animation summarising an object's history or how it works, a clip of the person who found it or of the landscapes and communities where it

originated? Do you need to explain how the objects were manufactured, the materials used, the symbolism of their decoration or how the whole thing looked if you only have part? Are there multiple ways of 'reading' the object, multiple perspectives on what it means or why it is important? Has its status in the museum collection changed with changing sensibilities and the uncovering of new information? Is it contested and are there other voices and perspectives that could be heard? There may be opportunities here to introduce multisensory and multimedia elements that will help to bring the object to life. Think of all the ways in which you can help the visitor understand the origins, function or meaning of an object, and perhaps, if it works with your themes, how it fits into a wider understanding of human cultures, history, arts and crafts, or natural and scientific phenomena.

The emotional journey

The emotional journey of the exhibition should be mapped alongside the main themes, stories or narrative. This is often referred to as pacing the exhibition, ensuring that the visitor journey is pleasant and doesn't bore or overwhelm. There is a real art to this, but having a well thought-through interpretation plan is the first step in making the exhibition a real success for the visitor. Think of the emotional journey as you would the plot of a story, with an introduction, scenes which build on each other, variations in tone and a satisfying conclusion. Try to include the stories of individual, named, diverse people wherever you can. People connect with people, even if the overall theme of the exhibition is something as non-personal as space science, world wars or the architecture of a historic site; giving the individuals involved in these subjects a voice will help your audience to connect. In the past, museums have been thought of as places for education, but now we understand them as having a much wider remit: they are places to spend leisure time, to socialise, to escape, to improve well-being and for much, much more. Museums compete to gain audiences from other sectors, including the arts, zoos and theme parks. They need to entertain, delight, provide opportunities for social interactions and participation, and they need to be places where big discussions can take place and ideas can be debated. Museums have to be relevant to people's lives, to discuss difficult and emotive subjects and to tread a careful line so as to present an accurate and honest version of the past and the present that can provoke discussion and curiosity.

Accessibility

Include consideration of accessibility in the interpretation plan. Maybe the

museum has an access specialist or a panel of advisers, but at any rate you should consider up front not only physical access to the spaces but how the stories and objects will be intellectually accessible to visitors. This will be an important part of the design brief as well.

Evaluation

In creating a comprehensive interpretation plan you will also need to consider evaluation. See Chapter 1 for more information on some of the basic techniques, but remember that in managing this part of the project you will need to set aside time and budget to allow for testing concepts and ideas with the audience. This will continue to be the case throughout the design period, and as your designers start thinking about how to turn the interpretation plan into physical form they may need budget and time to create prototypes and test some of the interpretive ideas on the prospective audience.

Case study 3.1: Prototype testing at the National Maritime Museum

At the National Maritime Museum in Greenwich, when the team were creating a new gallery for under-fives they built some prototypes of the interactive features and invited families in to try them out. This gave them a good understanding of what worked, what appealed to the age group and what needed to be more robust to withstand the interest of an enthusiastic toddler! This insight was invaluable for the design team, as it helped them to refine their ideas using real-world data.

The Double Diamond

At this stage it is useful to look at the Double Diamond innovation process. Developed by the Design Council and launched in 2004 and evolved in 2019, this method works well for creative projects, as it gives adequate time to the process of defining and developing an exhibition.

Using this process for an exhibition project runs something like this. You start with an idea, often just a very short summary of what the exhibition

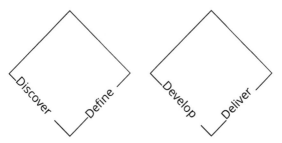

Figure 3.1 *The Double Diamond planning framework* (adapted from Design Council, 2019)

might be, perhaps in the form of a mandate document. The discovery phase covers the time when the exhibition is in its early form and you are working to flesh out the vision; lots of research is being done. This can include formative evaluation to test the audience's knowledge and appetite for the subject, and perhaps starting to engage them in helping you to create the exhibition. At this stage curatorial research into the objects and subject matter will also be going on. This is where things open up and all sorts of ideas can arrive on the table.

The *definition phase* is the creation of the project proposal or definition document and the interpretation plan, when you take all the knowledge and curatorial research that the team has gathered and start to refine it down to key messages, narrative journeys and emotional hooks. For example, you might be deciding whether to create a narrative for the exhibition or a series of themes. Decisions will be made about what to include in the exhibition and what not to cover. You will need to think about why you are telling the particular narrative, and how it relates back to your vision or big idea. Or, if you are creating themes, you will need to think about how they connect and why they are relevant. This is about who the exhibition is for and why you are doing it. Decide what it will say and how you can make that resonate with the passions of the audience, and how you can make it relevant for them. In this phase you start to narrow things down and make choices about what you want to get across to the audience and the connections and emotions that you will focus on as part of a unique exhibition.

Development brings in the designers and again opens up the process: lots of ideas can emerge about how the information and experience will manifest. As part of this final stage of the design process you will move through a series of steps to narrow down these ideas ready for *delivery*, leading you ultimately to the building of the exhibition and its handover for operational running.

Steps for putting together a plan

All this may seem overwhelming, so let's try to create some practical steps to creating a plan.

First, start with your formative evaluation. What do your visitors know and understand about the subject of the exhibition? Don't guess! Find out and make sure to work on getting answers from the audiences that you want to attract, not just your usual suspects. Gather the curatorial research and look back at the project vision, if it has already been created. If not, this is the time to get this into shape (see Chapter 1).

Second, list the questions that we have considered above, or use the interpretive planning tool of your choice and start to flesh out the sections:

Why. This is your 'so what?' question. Make sure you can answer it, as this is what will ensure that the exhibition has relevance to the audience and meets the needs of the museum's vision.

What. Compile the long-list of objects. What are the stars of the show, and how do they inform the why?

Who. Using the formative evaluation, detail who the exhibition is for and what they know and want to know.

How. Decide on the interpretive strategy. Will you take a narrative or a themed approach? Will it be in chronological order? Will it focus on one story or many?

Third, once you have decided on the overall approach to dividing up the content, make a start on that process. Decide what messages, connections or emotions each section will convey. Make sure to refer back to the project vision and objectives and that each of the key messages fulfils these. An approach that I find useful, if you have a list of the objects that you want to use, is to print pictures of them and place them on a large board divided into sections for the narrative, themes, story or emotional journey. Place the overall vision at the top and put each object in the correct place. Then list the key things that each object tells you about that section and think about how this relates to the vision. Make the objects earn their place in the exhibition! This will help you to decide what the top level of information should be for each object. Use bullet points to make an overall summary of each section. These can later become the guidance for some of the interpretation, such as an introductory panel, a short film or an audio-guide entry. Create a table listing the key messages for each section and object. You will need to consider dwell time. What is your target for the time visitors will spend in the exhibition? Now break this down into the lengths of time they will spend in each room, at each case etc. Check that the content plan isn't trying to over-deliver. Clue: it will be, and it always does at this stage. Don't panic, but instead do some basic calculations (Box 3.1 on the next page).

Fourth and finally, think about the interpretive devices that would work best for your different key messages. This may be best left until the designers come on board, as they will have ideas about how best to convey this information; but if you and the team have strong ideas about how you want the information to be presented it will be best to include them now. For example, you may want to convey key information about armour through doing. Can visitors feel the weight of a broadsword, for example? You don't need to design how this is done: just state that you want something interactive, and why.

Box 3.1: Estimating dwell time

To estimate dwell time for an exhibition, start by listing the word counts of written interpretations and labels, as shown in Table 3.2. At an average adult reading speed of about 200–250 words per minute, a written interpretation of 1,360 words have a dwell time of roughly six or seven minutes.

Table 3.2 *An estimated room word count*

Estimated written interpretation	Number of words per item	Total number of words
Room intro panel	120	120
3-section intro panels	80	240
20 objects	50	1,000
		1,360

Give visitors some time to walk around and actually look at the objects, and maybe to engage with one or two interactive features and talk to each other about what they are experiencing. Add in some time for this and consider whether it matches your targets or will create a bottleneck that will cause problems for the front-of-house staff. Of course, many visitors won't read every label or engage with everything on display, so if the estimated dwell time is around ten minutes and your target is eight minutes this will probably work. But if the estimate is 15 minutes and the target was five minutes, then you will need to start reviewing, prioritising and cutting.

Your plan will grow and develop with the design. Aileen Peirce, head of interpretation and design at Historic Royal Palaces, suggests producing the plan as a spreadsheet so that you can add columns as the project progresses; and, she points out, you can adapt this to form the basis for the graphics schedule when you get to detailed design stage. You could set out the plan as shown in Table 3.3, adding in details of the graphics, word counts and status of the text development in as the project progresses.

Table 3.3 *Suggested template for an interpretation plan*

Code	Room (working title)	Key messages	Secondary messages	Key characters	Key objects/ furniture	Suggested approach/ room overview	Notes

Based on plan produced by the Interpretation Department at Historic Royal Palaces for the representation of a set of rooms that were home to Queen Victoria when she was a princess at Kensington Palace.

Next steps

Once you have created the interpretation plan the next step will be to turn this into a brief for the designers. You can bring the design team on board earlier, but in my experience this can lead to the display being led by design

ideas, which will result in less powerful outcomes and the exhibition missing, at its core, a strong and well thought-through, visitor-centric narrative.

The design brief should include:

- a comprehensive outline of the project, detailing for the designers the project vision and definition;
- interpretation narratives/themes and the hierarchy of information;
- images of the key objects and, if possible at this stage, dimensions and any special display requirements;
- details of the spaces that the exhibition will occupy, including any visitor flow challenges, target dwell times, known pinch points etc. (check with the front-of-house team on this, as they are the experts on flow through the space);
- outline programme;
- outline budget for building the exhibition.

Interpretation doesn't stop with the interpretation plan. As well as planning out the content of the exhibition, this is a good time to think about how the content will be delivered, and by whom. It is helpful at this stage to include some key dates for text delivery, image research and editing. You will need these dates in your master programme, but it will also be useful to provide them to the interpretation and curatorial staff so that they can see what deadlines they will need to meet in order for production of the exhibition to run smoothly.

Gateway moment

The output from your interpretation planning work will be combined with your work to set up the project (see Chapter 2) and the output from the concept design phase (see Chapter 4) into the project execution plan (PEP) (see Chapter 12) that you will take to the project board or senior management team for approval. The creation of the PEP will be a significant gateway moment for the project, following which the project will move from the planning to the execution stage. At this moment you will be asking: 'Have we planned this exhibition as you expect and is it the style of exhibition you want to see? Are you happy for us to continue and start spending more money on making it a reality?' If the answer is 'yes', you will now move to the execution stage of the project.

Let's summarise

- One of the most essential elements of an exhibition project to get right is the interpretation plan. This should reflect the needs of the audience and make the subject matter relevant to them, while also conveying the values and vision of the museum.

- Creating a plan takes time, and you can use a number of different models to help, but at the core you should always try to make sure that you choose themes, objects and narratives that contribute to the exhibition vision and that can pass the 'so what?' test.
- The output of the interpretation planning should be an interpretation plan and a design briefing document that summarises the objects and the hierarchy of information that goes with them, along with ideas for how that information might be delivered.

Top Tips by Rebecca Richards, director of content and interpretation, Cultural Innovations

- Front-of-house staff have an excellent knowledge of your museum, the visitors, what works and what doesn't. They know if labelling is confusing, if the rooms are too cold or if nobody can find the way out. Consider having a representative from front of house on the project team, or regularly sharing progress with them and genuinely asking for feedback. It's unlikely that your project plan will answer all their concerns, but it's a great way of getting buy-in for the project and helping the wider staff to feel involved in the changes that they are a critical part of delivering.
- Don't forget to spend time in your exhibition after it opens, and not just for snagging! Observe what visitors are doing, what they are talking about, how they are using the space and how long they stay. This is no substitute for proper evaluation, but you deserve to see your work in action and what impact it has. Take your staff pass off first!
- Always keep your eyes open for interesting ways of engaging visitors – and not necessarily in museums. Look at how people are welcomed, communicated with and served, and how visitor flow is managed in retail outlets, theme parks, theatres or hotels, especially those that offer branded or 'immersive' experiences.
- Whenever you are writing anything and need to break off to do something else, stop writing in the middle of a sentence. It is somehow much easier to pick up the thread again when you come back. And revisiting something that you have written with fresh eyes is always useful!

Further reading

Beck, L. and Cable, T. (2011) *The Gifts of Interpretation: Fifteen Guiding Principles for Interpreting Nature and Culture*, Sagamore Publishing.

Black, G. (2005) *The Engaging Museum: Developing Museums for Visitor Involvement*, Routledge.

Brochu, L. (2003) *Interpretive Planning: The 5-M Model for Successful Planning Projects*, Interp Press.

Dean, D. (1994) *Museum Exhibition: Theory and Practice*, Routledge.

Falk, J. H. and Dierking, L. D. (2016) *The Museum Experience Revisited*, Routledge.

Roppola, T. (2013) *Designing for the Museum Visitor Experience*, Routledge.

Sandell, R. and Nightingale, E. (2012) *Museums, Equality and Social Justice*, Routledge.

Serrell, B. (2015) *Exhibit Labels: An Interpretive Approach, Second Edition*, Rowman & Littlefield.

Slack, S. (2021) *Interpreting Heritage: A Guide to Planning and Practice*, Routledge.

Tilden, F. (2007) *Interpreting Our Heritage, Fourth Edition*, University of North Carolina Press.

Veverak, J. A. (2015) *Interpretive Master Planning: Strategies for the New Millennium: Philosophy, Theory and Practice*, Museums Etc.

Wells, M., Butler, B. and Koke, J. (2013) *Interpretive Planning for Museums: Integrating Visitor Perspectives in Decision Making*, Routledge.

Bringing the Designers on Board and Creating a Concept Design

Introduction

In this chapter we will look at how to appoint the designers and what they will need in order to produce the concept design for the exhibition. The chapter doesn't provide a full description of all the tasks that need to be undertaken, but is an outline that will help you to understand what needs to be done and the key moments you will need to add to the project plan. By the end of this chapter, you should have a good understanding of the point where the exhibition process transitions from planning into execution, and you will know how to brief the key external staff that you will need to bring in to your project.

Appointing designers

The expertise that most often needs to be sought externally is that of designers. To create an exhibition, you generally need three or four types of designer: those who will create the structures and set works to display objects (3D designers); those who will design all your graphics (2D designers); someone who will develop any AV for you; and lighting design. Sometimes this expertise comes together in the form of a design company, but quite often you will need to recruit creatives from different sources to put together the exhibition. The 3D designers will design a wide range of things to make an exhibition come to life, from the positions of showcases in the room and the layout of objects within them and the label holders, to large pieces of set works that will create the environment for the exhibition. These set works can be as varied and extensive as your budget and space allows. The 2D designers will help you to choose fonts, colours and style for the graphics. The graphical language of an exhibition is very important in helping to set a tone and atmosphere for the display. Just think about the influence of graphics on our lives, such as the distinctive London Underground font, or the choices we

make when creating presentations. AV needs will be driven mainly by the content and interpretation plan, while lighting will be crucial to displaying the objects, quite literally, in the best light.

There are a number of approaches to bringing a designer on board. You may choose to bring them in early in the process to be part of the discussions about the overall vision for the exhibition. They can work with you as a partner in developing the outline narrative, choosing the objects and helping you to work through the processes outlined in Chapter 3 to create the interpretation plan. Some of the larger design companies offer interpretation specialists as part of their package, so if you don't have this skill in house it is a good idea to bring it in early in the process. If you are confident in producing an interpretation plan in-house, you could wait until your initial ideas are in order and then write these up as a brief for a designer to respond to. The approach you take will depend on how your organisation likes to do these things, its procurement process and the level of control that it wants to have over the vision for the exhibition. But when you reach the point of knowing the outline vision it is always a good idea to write a detailed brief about what you are looking for and to ask the designers to present some initial responses. You will then know whether they are thinking along the same lines as you and whether their ideas fit with your ambitions for the exhibition.

The design brief

As noted at the end of the last chapter, the brief needs to contain information about the proposal in general terms, but it should also start to be more specific about the objects you want to include, the interpretation plan and any interpretation methods you are considering. It must also contain some deadlines for the designers to work towards. At its core should be the vision or big idea and the themes, narrative or storyline produced in the interpretation plan. Again, you can do this with the design team on board, but if you opt for this approach be alert, and make sure that design doesn't start to lead the planning process. All exhibitions need to be underpinned with solid research and with a well thought-through narrative, story, emotional journey or set of themes in order to be truly meaningful to visitors. This will take some work – refer back to Chapter 3 on creating an interpretation plan. You should also include some information about the budget that is available – for details on how to start allocating budget, see Chapter 10. It is a good idea to give the designers a rough estimate of how much budget you have to build the exhibition. Their fee is usually based on a percentage of the build costs, so being up front with them about how much you have set aside for this will help you to understand how much the design

work is likely to cost and will provide them with a clearer idea of the scope of work they will be undertaking and the scale of your ambition.

Conversations to have with the designers

When embarking on the design for an exhibition it is essential for the design team to be aware of your budgets so that they will design something you can actually afford to install, and it is essential that both you and they think about the tone and feel of the space. You and the internal team could adapt your mood boards from the definition stage or create a Pinterest board to show the designers what sort of look and feel you have in mind for the space and the graphic styles that you and the team think would work well with the content. Collect ideas from other spaces that you visit to show the designers what you do and don't like. Think about interpretive techniques and what you think will work well for the content. Show the designers your ideas, but be open to new ideas and thoughts from them about what may work, as they may well have ideas that you haven't thought of or seen elsewhere.

Think about your approach to the objects in the exhibition and how you would like the designers to 'treat' them. Will the objects be the main media in the exhibition? Will they be used in mixed groups to convey ideas?

Selecting the designers

Once you have decided when to bring designers on board and started the procurement process you should interview the short-listed designers to find out if they will be a good fit with the team and if their design ideas excite you and respond creatively to the brief. It is usual to ask designers to come up with an outline idea – perhaps for how they would present one theme or key object – to present at interview, as well as asking them to present examples of their previous work for you to see. You might also arrange an informal walk through your spaces, which will be a time when you can answer any questions they may ask about the brief or the space.

Your museum will have thresholds for the values of work that must be put out to tender. If this is a formal tendering process, you need to record all the questions asked and answers given during a walk through, and if these aren't specific to the one designer all the questions and answers should be shared with all those participating, in order to ensure that you aren't inadvertently giving one designer an advantage over another.

You will also need to familiarise yourself with health and safety rules. In the UK this means getting to know the Construction (Design and Management) Regulations 2015 (CDM Regulations) and understanding your

duties as a client and the role of the designer in the process. It is likely that you will need the designer to become a 'principal designer' and take on the responsibility for ensuring that the project is delivered safely, as this is a requirement of the legislation if more than one contractor is involved. In most exhibition builds there is more than one contractor; for example, a specialist showcase contractor, a set works contractor and a graphics contractor. In such a case you would need to appoint your designers as 'principal designer' under CDM Regulations and you, as PM, would need to take on the role and responsibilities of 'commercial client'. This isn't as daunting as it sounds, and there is plenty of training and guidance available. For a start, see the Regulations (Health and Safety Executive, 2015a), and refer to Chapter 6 for more about CDM.

You may want to ask the designers to come up with more than just a few outline responses to the brief. If that is the case, you should agree to pay a short-list of a few design companies a small fee to come up with some more developed concepts which would provide a clearer idea of their response to the brief. If you do go down this route you must give the designer enough time to carry out the requested concept work. Using this approach can help if the timeline is tight, as you can collapse part of the concept stage (see below) into the tender period and this will gain you a couple of weeks. It may cost a bit more to do it this way, but you will be receiving more developed and considered approaches to your brief.

Once you have chosen the designers and agreed their fee, you will need to set up a project start-up meeting, where you will review all your ideas for the exhibition with them in detail and usually walk through the spaces together.

The interpretation specialist

It is important to compile a detailed object list which can be passed on to the design team along with the interpretation plan. If your team is large enough, the curator will work with an interpretation specialist, or you may need to bring one in. You may in fact already have engaged with an interpretation specialist when creating the interpretation plan (see Chapter 3). This person may come from a design studio; there are also plenty of freelance interpretation specialists.

The interpretation specialist has the needs of the audience at the core of their practice and will work with the curatorial team to narrow down the object long-list so as to best illustrate the points the exhibition is highlighting as set out in the interpretation plan. The object list should include images and the dimensions of each of the objects, details about how they can be displayed (e.g. whether they must be kept flat, need a specific type of mount, can be

attached to a board with magnets etc.) and some notes explaining why they are included in the exhibition and their place in the narrative. Even though the object list and the full interpretation plan may not yet be fully decided, the more detail you can give to the designers the better, as they will respond to it creatively and come up with ideas that you won't have thought of. Your role as PM will be to agree the date by which the final object list is agreed and issued, after which no further changes will be made. Changing objects and narrative once the design process is underway will start to cost the project extra money and should be avoided if at all possible.

2D and 3D designers

If you are asking 3D designers to pitch for exhibition design, it is likely that they will bring a 2D designer with them. Often, design companies have both types of designer on their books; if they don't, they will have good contacts with freelancers with whom they will team up to provide a full design service for an exhibition. This will work well if you are designing a temporary exhibition, but if you are doing something bespoke or unusual, such as a room re-creation, then rather than an overall designer you may use a number of makers such as furniture makers and textile specialists alongside a 2D designer's services, with the overall direction of how the room should appear coming from your curatorial or in-house design team. In such a case each member of your design team will have the different skills required to make the elements needed to dress the room. These makers will work with the team to create an overall room design. The graphic design will likely be only a small element that comes later in the process, or it may be integrated into some of the set dressings, such as cushions or blinds. In this case a 3D designer may not be necessary.

Communication with the designers

As PM, you need to keep the programme for the design work on track. This will mean making sure that the designers have all the information they need in a timely way. Has the curator finished and issued the object list, and does it contain all the dimensions etc.? Have the designers been provided with a pack of measured and scaled drawings of the space they are designing for, or have you arranged a site visit for them to take the measurements? Do they need drawings showing the locations of electrical sockets, and details of the kind of lights on the lighting track, if you have one? Has the interpretation plan been signed off and issued? This is where really good communication comes in. You will need to be the main point of contact, so that if the designers

have queries they will have just one person to ask and it will be clear who the answer is from. This will avoid the confusion of lots of team members jumping in to answer e-mails and will ensure that decision making is transparent. You will need to make sure to keep good records of what information has been issued to the designers and what is likely to be needed, so that the other members of the team are focused on delivering the required information on time.

The design stages

In the exhibition world there are usually three stages to the design of an exhibition:

1 concept
2 scheme
3 detailed.

We look at concept design in this chapter, and scheme and detailed design are the subject of Chapter 5.

Concept design

Concept design is about working up the vision for the exhibition into a rough idea of how it will be presented in the space. Often at this stage the designer will come up with lots of outline options for the team to discuss and think about. Recall the Double Diamond planning model from Chapter 3? This is the phase where things open up. Key questions will include how visitors will flow from one section to another; the position of showcases or walls or other large set works; and how the narrative, themes and emotions you want to convey will map onto the space. These are all outline ideas, sometimes with suggestions for some of the materials that might be used or the techniques (sound, AV, film, lightboxes, large images etc.) that might be employed to bring the objects and story to life.

It is a good idea at this stage to keep referring back to your overall budget and the costs that these concept designs might incur, as well as to the interpretation plan. For example, will the proposed number of showcases use up your entire build budget? Do you want to spend more on AV elements? Many ideas will come up at this stage, but not all of them will make it into the final design. At this stage the designers want to get a feel for what the team, as representatives of the museum, like. Throughout the design process you, as PM, need to be ready to provide feedback on the options quickly,

summarising the comments from the team. Any differences in the team's opinions need to be managed, and clear, consistent feedback needs to be given. You need to articulate who will be making the final decisions and the points when these will be made. Remember that the exhibition is part of the museum as a whole, and, when evaluating ideas from the designers, consider not only the flow around the exhibition space but how they will fit in with the rest of the museum space, ensuring that accessibility for all has been considered. It is at this point in the design process that your RACI (list of those responsible, accountable, consulted and informed) will really start to come into its own, and all the work that you did to set up lines of reporting and accountability will become really worthwhile. See Chapter 2 for more on this.

You may have more than one idea or options to show to the project board or senior management team before you settle on the concept that you want to take forward. It can be hard to narrow down and agree on ideas to take forward. If you are struggling to reach agreement as a team, then refer back to the vision and objectives. Ask yourself if the design is meeting the objectives, and remember that this is not a subjective process based on the individual taste of team members – it is about agreeing on a design that will best meet the needs of the visitors and the museum.

From a broad range of ideas you will funnel down to one that will be worked on in more and more detail until it is ready to be built. It can be all too easy to continue coming up with ideas and avoiding making decisions, which will just lead to a delay in the process, so agree with the design team on how many weeks you will spend on concept design and set up all the meetings and discussion workshops that you will need before you start. You can then be sure that all the right people will have input and that there will be a clear decision moment when everyone on the team will be ready to agree on the concept and move to the next stage.

Gateway moment

The output from your work with the designers on the concept design will be combined with outputs from the project set-up work (see Chapter 2) and the interpretation plan (see Chapter 3) into a project execution plan (PEP) (see Chapter 12) for approval by the project board or senior management team. The creation of the PEP will be a significant gateway moment for the project, following which the project will move from the planning to the execution stage. At this moment you will be asking: 'Have we planned this exhibition as you expect and is it the style of exhibition you want to see? Are you happy for us to continue and start spending more money on making it a reality?' And if the answer is 'yes' you will now move to the execution stage of the project.

Let's summarise

During the concept design process:

- you will have understood the different types of designers you may need to appoint, including 3D and 2D designers, who will come on board either with a design company or separately;
- you will have decided with the internal team when you want to bring the designers on board and whether you want to involve them in helping to create the interpretation plan;
- you will have chosen and assessed designers to make sure that they will be a good fit with your vision and team, using interviews, looking at their previous work and asking for a sample creative response to your ideas –either as a concept for which you will pay a small fee or as a rapid initial response to one of your ideas;
- you will have created a workable plan for the delivery of this stage, including a list of what information you will need to provide and when, so as to ensure that the designers can do their job;
- you will have one or two concept ideas to form part of the project execution plan, which forms the gateway into project execution or delivery.

EXECUTING THE PROJECT

We now move into the execution stage of the project. This is the stage that most people commonly associate with exhibition project management. The designers are at work, loans start arriving and the exhibition is built. In Part 3 we will look in more detail at the design process after concept design, and what you need to do to manage the on-site work successfully. At this stage the project starts to become visible to others in the museum. It can be fast paced and sometimes quite physically demanding as you spend more time on site than in the office. You will need to carve out time to keep the paperwork in order, keeping the programme on track and being meticulous about the budget and risk management (for more on this see Part 6, Key Project Management Skills). The two chapters in Part 3 look at the second and third stages of the design work – scheme design and detailed design – and the work on site as the exhibition is built.

Scheme and Detailed Design

Introduction

In this chapter we will look in more detail at the design process, examining the activities that take place in scheme design and detailed design. We will also look at how the design stages map onto the architectural project management framework of the Royal Institute of British Architects (RIBA) Plan of Work, so that if the exhibition is part of a larger museum refurbishment or you are using one of the larger design companies you can understand how this framework fits in.

Scheme design

At the scheme design stage things start to be firmed up; the exploratory phase of the design has ended. You have approval for the concept and how you will implement the project. Now the designers will focus in more detail on the chosen option. In this stage they will fix the position of the showcases and start looking in more detail at where AV and graphics will be sited. They will start to design in more detail the display of the objects within the showcases and how those objects that are to be on open display will be presented, and they will consider any interpretive or design elements that you may wish to include. They will start thinking about how the set works might be created and will work with you to develop the concept further, thinking about the materials they will use, the colours and some of the details like where the graphics will go, the position of objects and the design of the set works. They will also consider the services (electrical, data etc.) that will be needed to bring the concept to life. Questions to be considered will include: are the showcases in the right places to get power? Is the floor loading sufficient for that bit of set works? Where will the graphics be sited? What will the colour scheme be? Which materials will work with this design?

It is at this stage that some elements may be prototyped and tested on visitors. The curators and interpretation specialist may start writing some sample text and, with the 2D designer, trying out fonts in the sizes that they think will work in the space so as to get an idea of word counts and how things will look. The team will need to start choosing images or film clips and narrowing down the content that will be included, and they will identify where in the exhibition the various media will go and what additional content will need to be created, such as bespoke films, interviews or infographics.

Quite often the scheme design process means that some things adapt and change from the outline concept. You may find that all the objects envisaged cannot fit in a certain area, that a showcase cannot go quite where you imagined or that the colour everyone liked in the concept doesn't really work with the objects and needs to be reconsidered.

Checking costs

Before the scheme design is finalised, you check the costs. Is the design within budget? If a QS is working with you it is a good idea at the end of each design stage to give the QS some time to cost the proposal so that a formal response on the ideas and their cost can be given to the design team. You may need to ask for something to be cut, or for the designers to work with you to reduce the cost of a particular element, but this should be done throughout the process and not left until your tender prices come in. If you don't have a QS, then you will need to try to estimate the design costs yourself. The design team can help with this, because it is likely that they will have used some of the proposed techniques before and can give a rough estimate of how much they cost. You can also refer back to previous exhibitions, and also ask colleagues to help you estimate how much particular elements might cost. You could even contact some suppliers and request a ballpark estimate for those elements that you are unsure of. An internet search is sometimes very helpful at this point. (For more on managing cost see Chapter 10.)

If it appears that you will end up going over budget, identify those elements of the design that would be 'nice to have' and can be cut, while making sure that you retain the key objects, the core narrative and the look and feel you are aiming for. Your design shouldn't have deviated far from the concepts you had approved at your last gateway, but they will have developed. Check with your senior team if they want to see the designs again at this stage, although the end of scheme is not a formal gateway, it is a milestone in this project management framework and you should mark it as such and remind those involved that they are signing off a design and moving on to a new stage in the design process; once you are into detailed design, changes can be

expensive. If there has been a significant change to the concept during the scheme design, you will need to go back and get approval from your project board or senior managers to proceed, as the finished product won't be what you had approval to produce.

Detailed design

At the end of scheme design the design is 'frozen'. This means that you are happy with the arrangement of each room and showcase and the overall flow of the exhibition. Now the designers will go into real detail about each element: what materials will be used, how the graphics will be attached, exactly how each showcase will be laid out and what mounts will be needed. They will design the set works fully, preparing detailed scaled and measured drawings illustrating how the designs should be built and what materials should be used for each element. By the end of the detailed design stage you will have a pack of drawings covering every single element of the exhibition. You will have been on site with the designers and looked at materials in the space and chosen the finishes and colours, the fonts and their sizes. The team will have sourced and secured any necessary licences for images; any graphics such as timelines will have been designed and text will have been written and will be set by the graphic designer (sometimes the deadlines for the graphic design are a little later than for the 3D drawings, but don't leave this too long; the more you can get finished at the detailed design stage, the easier the installation will be). You will hand this pack over to an exhibition build company, who will, if necessary, work the drawings up into workshop drawings from which they will fabricate the exhibition and then install it on site.

Working with architects

Sometimes exhibitions are designed as part of a larger museum refurbishment and you and the exhibition design team will be working alongside architects. It is useful to know in this case how your work fits in with the architects' plans. You will need to liaise closely with the architectural team so that they can accommodate the needs of your designs in their plans. The architectural team will usually decide where electrical outlets will be and what spaces will have access to data services. These decisions are crucial to exhibition designers, because if the electrical or data services are not in the right places this will limit where AV installations or showcases can be placed. Work closely with the architects to understand what information they will need and when, so that this is clear in your own programme.

Exhibition designers often use a different set of terms than architects do, simplifying their process into the three phases of concept, scheme and detailed design, but architects usually have more stages in their design process.

In the UK, architects generally use the Royal Institute of Architects (RIBA) Plan of Work, which has seven phases. Stages 2, 3 and 4 are roughly equivalent to the concept, scheme and detailed design phases that we have explored. In the RIBA Plan of Work 2020 these are named Concept Design, Spatial Coordination and Technical Design (Table 5.1). If you are working alongside architects you will need the exhibition designers to have reached at least partway through or, ideally, the end of scheme design at the point when the architects start on their Stage 3 Spatial Coordination. This is so that they can fix the locations of all the services (electrical, data etc.) that will be needed for your exhibition during their construction phase.

Table 5.1 *The museum design process and the RIBA Plan of Work*

Museum design process	Summary of the stage	RIBA stage
Concept design (some of which can be produced as part of paid pitch)	Early ideas, plotting the overall exhibition route and ideas for the look and feel	Concept Design
Scheme design	Developing the concept, placing objects and showcases and firming up interpretive techniques. If working with an architect, this will be the time when you agree on the location of services (electrical, data etc.)	Spatial Coordination
Detailed design	Final design drawings of all elements of the exhibition, ready for it to be built.	Technical Design

If your exhibition is part of a refurbishment or building project, there is likely to be a pause in exhibition work while the architectural or base build work is completed. It is therefore important that you work with the architectural and buildings team to co-ordinate your programme with theirs. Any project breaks need to be carefully planned into your programme and reflected in the agreements and contracts you make with the designers.

Working to produce an exhibition in house

You may be in a position where you can't afford a design team and the services of an exhibition build company. In smaller museums it is often the case that existing cases are reused, with the set works being made by trusted volunteers or members of staff who have the required skills. If this is the case, then the

design process is likely to be less formal than outlined above, but it will probably follow a similar path. You will try out different ideas, perhaps laying out the objects on tables or shelves to work out the look and feel that you want to create (concept design); you will probably print out some sample text that you have created and try different colour backdrops with your chosen layouts (scheme design); finally, you will describe to someone how to put it all together, plan how to install the display and finalise the images and text (detailed design).

Whichever your route, make sure to pick moments in the process to pause, consider what has been done so far and decide as a team to accept this and move on.

Case study 5.1: Displaying objects

Different types of museums treat objects in different ways. In the Victoria and Albert Museum or the British Museum the permanent galleries often have much less set dressing, and all the emotional content and information is focused on individual objects or small groups of objects in cases. In the example in Figure 5.1 from the National Museum of Scotland's Natural World Galleries, big questions about how the world works are explored through an object-rich display.

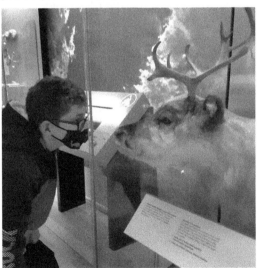

Figure 5.1 *The author's son enjoying an object-rich display at the National Museum of Scotland* (picture author's own)

Leeds Castle in Kent has opted for room sets to tell its story, setting up rooms to illustrate a moment in time. By mixing objects and set dressing they hope to elicit an emotional connection to the people who lived and worked there, and create a feel for the changing use of the castle through the ages. Many country houses take this approach of 'dressing' rooms to give the impression that their owners or users have only just left the space.

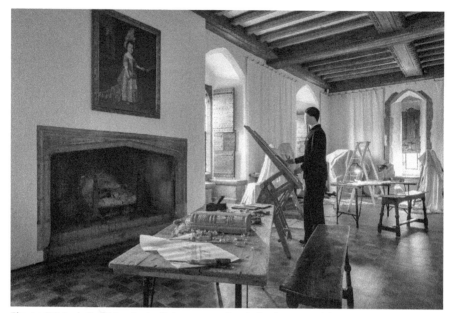

Figure 5.2 *Lady Baillie's private dining room at Leeds Castle, set as if during the restoration works of the 1920s* (copyright Chris Lacey Photography)

Some spaces mix objects, images, film, set dressing and other media to tell a narrative such as in the 'SoapWorks' exhibition at Port Sunlight (Figure 5.3).

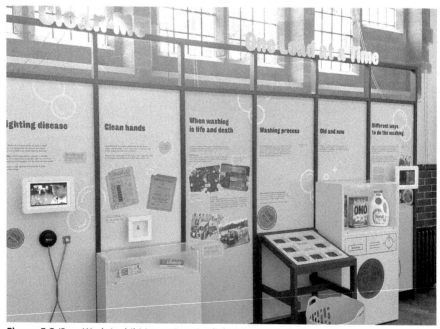

Figure 5.3 *'SoapWorks' exhibition at Port Sunlight* (picture author's own)

If you are working with an audience to create the exhibition, what are their views, how will these be represented and what media do they think will work best? You will want to discuss with the designer what will be the best moment to set up some prototype tests and evaluate the audience reaction to different ideas for the show.

Think about how you see the exhibition best achieving its objectives and the ways in which you want to get your interpretive messages across. Is the team still considering the needs of the audience and incorporating different perspectives to make the display truly inclusive? You may wish to use different approaches in different sections, or you may decide to stick with one approach all the way through. If you want visitors to contribute ideas, how will this happen? Be prepared to discuss this with the designers and to be challenged on it if they have different ideas. Much of this work can be done as part of the interpretation plan (see Chapter 3). You should also return to your thinking on sustainability, questioning the design team so as to encourage them to choose materials and methods with suitable 'green' credentials. Think about what will happen to elements of the exhibition after it is over. Are there things you can build into them now to make them more reusable? Start gathering information on sustainable practice and try to build this into the design. Finally you need to continually review the accessibility of the exhibition. Will wheelchair users be able to move about freely and see all the objects; have you included subtitles and/or sign language interpretation on films; are there tactile or other sensory elements; and have you considered large print guides?

Let's summarise

The key points for you as PM in the design process are:

- to keep an eye on the design and the build budget. Do they work together? If not, what can be changed to bring them back into line? This should be a collaborative piece of work between the design team and the museum team. At the end of it, who in the museum will make the final decision on what stays and what goes? Make sure that this is agreed in advance as part of the project set-up (see Chapter 2);
- to create a workable plan for the delivery of each stage – concept, scheme and detailed design – including allocation of work for your team members and deadlines for handover to the designers of images, text and information;
- to co-ordinate feedback at the end of the stage and deliver it clearly to the team;

- to freeze the design, making sure that all team members are fully aware of this and what it means.

On Site

Introduction

In this chapter we will look at the role of the PM on site, when a project is being installed in the gallery space. From setting up the space to considering health and safety on site, we will consider the sequencing of work and the importance of change control. This is a busy part of the project where you will need to be present on site regularly and keep careful control of what is happening.

Preparing the space

This is the most exciting part of the project, when you see all the hard work that has been put in so far start coming to life on site. You will need to get some things in place before construction starts. It is important to set up the site so that work can be carried out efficiently and, even more importantly, safely. Begin by thinking about the types of space that will be needed to make the installation go smoothly.

You will need spaces where loaned objects can be delivered safely and where objects from your museum's own store can be unpacked and sorted, ready for display. For large exhibitions you may need somewhere to unload trucks and isolate loaned objects before they are brought into the space. You will also need somewhere to store the materials in which loaned objects are packed. These may be quite large boxes or even crates. The space doesn't need to be right next to the exhibition space, but it will help if you don't have to transport things too far, as it's not much fun having to carry empty, awkward-shaped boxes from one end of your museum to the other at the end of a long day of installation work.

As well as storing the objects safely you may need to make frames or mounts for some of them before they go into their showcases. Where will this happen? Will they all be made on site and, if not, do you have room for them all to be delivered at once?

Can you set up a temporary office near the exhibition space for staff who need to do documentation work and for you, the PM, so that you can keep an eye on the activity happening on site each day?

Will you be photographing the objects for a catalogue or a book? If so, where will you set up for this? The photographer will need a dedicated space and good lighting.

Do you have security staff on site and do they have all the space and equipment that they require before work begins, such as well-positioned security cameras or locks on the main doors?

For the contractors who will be building the exhibition you will need to work out routes to and from the site, as you probably won't want to have them walking through the main museum or carrying equipment and materials through the galleries. You will also need to provide them with welfare facilities, which should include men's and women's toilets and changing spaces, along with a space for them to take breaks and eat their lunch. This should be separate from the public facilities and, if possible, different from the staff provision. If you have a bigger build or a longer programme you may need to consider bringing in some temporary cabins or toilets (this is often done as part of the contract with the construction team, but you will need to remember to budget for it).

Figure out what activities need to happen on site and how people will access and use the spaces before you bring a contractor on board, so that you have a clear plan of what spaces they will have access to and where your own team can work.

Selecting a contractor
Reviewing quotes

Once you have worked out these kinds of logistics and have a detailed design it is time to bring in an exhibition build company or to brief the in-house team on how the exhibition will be built. If you decide to employ a contractor then you will probably need to conduct a competitive tendering process or obtain quotes for the work (you should always try to get three quotes, and for most exhibition builds you should run this as a formal tender). The tenders or quotes will be based on the drawings that were produced by the design team, so you and the team will need to be sure that you have checked these drawings and that they cover all aspects of what you want to create. As PM you should know these drawings inside out and be satisfied that they will work for your space. Usually, to accompany the drawings you will create a pricing sheet, listing each element of the exhibition so that a price can be given for it. This will help when you study each tender or contract submission, as

you will be able to see if one company is charging more for a particular element and can investigate at interview why this is so.

If you have a large or complex build, the services of a QS who specialises in exhibitions or of a professional museum project management company can be invaluable at this stage, as they will create detailed pricing schedules for you. If you employ a PM company to manage the build, they will oversee all the health and safety regulation, build quality, timings and cost for you. If you are both the PM and also the curator or have another role, this is probably the time when outsourcing some build specialist help will be worth the investment.

Alongside the costs for each element, the contractors will usually include a number of site start-up costs in the build price that they give you. These are known as preliminaries and are the costs incurred by the contractor that are specific to your site. They can include things like the hire of machinery or scaffolding, the hire of welfare facilities, any administration costs relating to carrying out the work and miscellaneous costs related to the contract such as a skip for rubbish.

The contractor will also add an overhead and profit (OHP) to their costs. Rather confusingly, the overheads in this title don't refer to the overheads already mentioned in the preliminaries; rather, they refer to the kinds of overheads that the contractor incurs in running their company from day to day, which they need to consider when working out what sort of profit they will make from the work they do for you. Most contractors in the UK add a percentage OHP cost to their work. When you put together a request for a quote or tender it is worth asking for the OHP percentage to be listed separately to the build costs. This way, you can both compare the build costs of each company and see the amount of profit each expects to make. Compare the costs that you get from the companies and ask them for clarifications if there are large discrepancies between quotes. Some companies include different elements than others in their OHP calculations. Don't be afraid to ask what is and isn't included, so that you can compare like with like.

Interviewing

When you interview the build team ask about their thoughts on how they will build the exhibition. They may have ideas for more sustainable materials or ways to alter designs so as to save money without changing the design intent. Often, museum designers will know what they want to achieve but the method by which that is fabricated can benefit from the input of a contractor who has been putting this sort of thing together on site for years; the ideas they suggest may be things you or the designers have not thought

of. By talking to the build team you will also form an idea as to whether they are the sort of people you can work with, who are aligned to your museum's way of working and will work with any rules you have in place. Make sure to ask for the interview to be attended by the people who will be in charge on site, so that you get to meet those with whom you will be working and not just a team who are there to help sell the company.

For larger projects you will need to think about the kind of contractor you use, as you can take a number of different routes when employing a build contractor. The most common is to employ one company to oversee the work (under the CDM Regulations this is known as a 'principal contractor', see more below), and that company will subcontract to others any work they cannot do themselves. They will likely suggest in their tender what subcontractors they might use – or you can ask about this at interview – because often they will work with the same subcontractors on a regular basis.

Do some background checks on the companies that you invite to quote. Look at their websites to see if they have experience of working in a museum or heritage site like yours, check out their subcontractors and if possible go to see some examples of exhibitions or displays they have constructed elsewhere to check if you like the quality and finishes of their work. If you can, have an informal chat with the museum about how they found working with the company. If there is something you are not happy about from these visits, talk to the contractor about it. For example, you may see an exhibition where the AV didn't seem to be of a good quality and you are concerned about this for your own display. It may be that the client had to save money and cut back on the specification; or perhaps this element was subcontracted, in which case you could ask if they could engage a subcontractor with the look of whose work you prefer. If your exhibition has AV elements or interactives you will also want to know what the call-out terms are if something goes wrong. How long from getting a call will someone be on site to fix it; are weekends covered or do you need to pay a supplement for this; can you negotiate a package of call-out options and maintenance so should something go wrong, the museum will not be without an element or elements of the exhibition for too long?

This is the stage when you can ask lots of questions and negotiate for what you want.

The contract

Once you have carried out the interviews and negotiated the final price for your build, it is time to engage the contractor. Make sure at this stage to use a robust contract for the work and to include all the relevant health and safety information about the site and in relation to your local health and safety

regulations (if you are in the UK, see below for the CDM Regulations). It is likely that there will be more than one contractor on site, especially if you are installing showcases, in which case you will need to make your contractor a 'principal contractor', which will make them responsible for the site.

If you do lots of changing exhibitions and don't have an experienced procurement professional on the team, then it is worth getting some advice from a legal expert and using or creating a template contract that can be adapted for each exhibition you put on, adding the drawings, programme and agreed pricing schedule submitted as part of the quoting or tendering process to the contract for each new exhibition.

You will need to consider when you will pay the contractor. Often they will need a percentage on signing the agreement so as to be able to start buying materials, but be careful not to pass on too much money early on, because if things are not delivered it can be hard to recoup the loss.

Box 6.1: Retention

A retention is a small sum, perhaps 3% of the costs, which you hold onto until the end of the exhibition – if it is a short run – or for three to six months after completion of the build work if it is a permanent change. By holding back this sum, if the snagging doesn't get remedied or the contractor goes out of business you will have some money set aside to pay for this work.

It is also a good idea to plan for at least one visit to the contractor's workshop to see the work in progress and assure yourself that things are progressing as planned and are to the quality you expect. Plan your visit(s) as part of the programme for the build.

Sequencing the work

The contractor will produce a programme that shows the sequence in which they will install each element of the display. However, this won't necessarily include all the elements that are needed to finish the work, as it is likely that you will do some of this in house. For example, it may well be your conservation or curatorial team who will install the objects, and you may have a separate graphics contractor who will come in to install the labels (although this can be part of the main contract as well). Make sure that you have plotted out the work that will need to be done after the main build.

When you negotiate timescales with the contractor leave enough time after they hand over the completed build to carry out any in-house installation, photography and training work. If you are using showcases you may need to schedule some time for that all-important period of 'off gassing': most

fabrics and inks used in the production of baseboards, labels and, in some cases, mounts need time to disperse any lingering chemicals before it's safe to insert the objects and seal the case. In fact some materials will require testing before they are approved to go inside showcases which can also take time. Don't forget this crucial downtime, and see that it is built into your own and the contractor's programme. You will need to add the contractor's programme into your own and monitor progress carefully so that you are not left cramming the object installation into the night before opening!

Finally, you will need to programme in some time for your front-of-house colleagues to familiarise themselves with the space and understand how various elements of the exhibition work. You need to schedule time between finishing the installation and opening day so as to accommodate press days or any special preview days that you want to run, as well as time for opening events and photography. The day that the build contractor finishes should not be the day before the exhibition opens!

On site

Now comes the bit that everyone has been waiting for: things taking shape on site! This is where your role as PM is crucial to the success of the project. You have the difficult job here of seeing both the big picture – the exhibition needs to be ready on time for the opening date – and the granular detail – is that trim on the case the right colour? I like to base myself near the build and check in with the contractors first thing each day on what they are planning to do, and last thing to see if they achieved what they hoped. If it is a big build, this daily checking in can become too much and you will need to judge what feels appropriate. Whatever pattern you choose, the team on site need to know that you are watching and are there to help when they come across a problem, as they invariably will.

Change control

Often when on site you will be asked for your opinion about something. You may feel pressured into making a decision while the build team stand around, waiting for you to pronounce which way to go. Always take a step back and consider whether this is something you need to decide on the spot. Do you fully understand the implications of it? Do you need input from the designers? If you are not certain of the correct response, ask for some time and ask the build team what else they can get on with instead. Consider how critical this piece of work is to the overall progress and how much time you have to make a decision.

To keep things under control, make sure to put in place a robust and efficient system that will allow the contractors to report when they need to make changes from the agreed schedule or designs and what effect this may have on the quality, programme or cost of the exhibition. By being accessible and visible to the build team and establishing a good relationship with the site manager you will avoid getting into contractual disputes later in the process. If you know what decisions are being made and are very clear that when changes affect cost only you can approve them, then you will have a clear picture of exactly what is happening and how it will affect your budget.

If, when you are on site, a matter is brought to you that is straightforward and you can answer it, do so and then follow it up in writing. Make detailed notes of all the discussions you have on site and remember to keep the decision register and change control forms up to date (see Chapter 10 for more on this). Remind the build team of the process for implementing variations and don't let yourself be forced into making a snap decision that may cost you down the line.

You will also need to be clear with your team about the change control process and who can issue instructions on site. Difficulties can come if members of the team feel that they can discuss details of the build with the contractors on site and this is then interpreted by the contractors as a client instruction. Encourage your team to discuss any concerns they have about the build with you first, and not directly with the contractors. And make sure that the contractors know that only you can issue instructions and that these will always be in writing so that there will be no confusion. Give the contractor permission to push back if someone comes along and asks them to do or change something that isn't part of their agreed work.

If you can, hold a regular meeting with the contractor (depending on the length of the installation this might be daily, weekly or monthly) to go through any issues arising. Have the designers present at these meetings together with key members of the internal team. Use the meeting to review any changes and agree with everyone on the best course of action. Follow this up in writing. For larger projects this should be done through a variation to the contract or via an agreed change control procedure.

Health and safety

All build comes with risk, and one of the big risks is to the health and safety of those who are working on it. As PM you will be responsible for overseeing the health and safety of all those working on the build and accessing site. Depending on the size of the project, you will need to follow a number of regulations and health and safety practices. In the UK, if the project is big

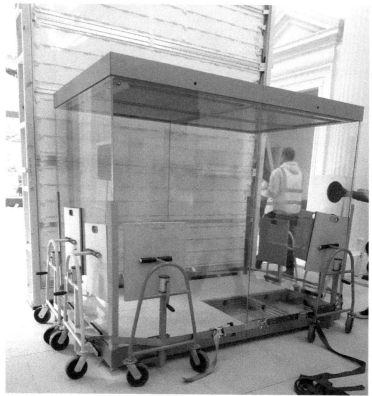

Figure 6.1 *Case installation during 'Royal Style in the Making' at Kensington Palace, HRP*
(photo author's own)

enough the work will fall under the CDM Regulations 2015 (refer to the Regulations to check the rules on this), and it is vitally important that you understand what this means for you and the museum. At their most basic, the CDM Regulations set out the responsibilities of all the different parties involved in a construction project – which most exhibition builds are. As the person instructing the work, under the CDM Regulations you are the 'client' and will have a number of duties and responsibilities that you must fulfil. Make sure to familiarise yourself with the Regulations and understand your duties as a client. Guidance on these duties can be obtained from the Health and Safety Executive. It is worth going on a training course if you are unfamiliar with them, as non-compliance can lead to serious consequences.

The client's responsibilities

The duties for the client include making sure that the right 'dutyholders' (a term covering all the named roles under the legislation) are appointed for the

work. These include a 'principal designer' and a 'principal contractor' (Table 6.1). They also mean that you, the 'client', will need to: ensure that there are sufficient time and resources to carry out the work; pass on information to the right people at the right time; make sure that the other key 'dutyholders' carry out their duties; and provide adequate welfare facilities for those on site.

Table 6.1 *The key CDM duties and how they relate to a museum exhibition project*

CDM role	The exhibition project
Client	The museum's lead representative, usually the internal PM. Responsible, among other things, for passing on relevant information to ensure that the design meets health and safety regulations. The PM must also appoint the right dutyholders, including a principal designer and principal contractor if required. They will also need to review and monitor the information produced by the 'principal designer' (pre-construction health and safety plan) and the 'principal contractor' (construction phase plan).
Principal designer	When there are a number of designers on the project one will need to be the lead designer and ensure that all the drawings are co-ordinated and the health and safety regulations are being followed during the pre-construction phase. Often this will be the 3D designer. They must pass on all relevant information to the 'principal contractor'.
Principal contractor	This is the lead contractor building the exhibition. They may subcontract work to others (such as electricians), but under the CDM Regulations they are responsible for site safety. They must produce a construction phase plan which includes details of all risks on site and the measures to mitigate them. This plan must include information provided by the 'principal designer'.

The 'client' must also appoint designers who will take on the role of 'principal designer' if there is more than one designer employed for the work (for example, separate 3D and 2D designers or an architect as well as an exhibition designer). The 'principal designer' has to 'plan, manage, monitor and coordinate health and safety during the pre-construction phase of the project' (HSE, 2015b, 6), as well as provide information to the 'principal contractor' or (if there is only one build company who is not subcontracting any work) 'the contractor', to help them manage health and safety during the construction phase.

The principal contractor

The 'principal contractor' is appointed by the 'client' to coordinate the build work and they must, among other things, prepare a construction phase plan, which should contain information on health and safety during the construction phase, including what measures have been put in place to

manage specific risks (these could include things like working at height or the management of dust or hazardous chemicals). This plan must be produced before the construction site is set up and must include information from the principal designer. This is when you, the client, will receive from the contractor a plan of their work, including all their risk assessments and method statements. These should be site specific and include the information that has been provided to them via the principal designer about any risks and potential hazards such as low doorways, cable routes in walls where they may be installing fixings or the use of particular materials specified by the designer.

Ensuring safety on site

This all may seem overwhelming, but it is mainly about ensuring that the workplace is as safe as possible for those working on site and that mitigations have been put in place to protect people. Just reading this part of the chapter isn't enough. Wherever you are working, if you are not already familiar with either the CDM Regulations if you are in the UK or their equivalent in your own country you must do more research and be sure that you feel confident to manage this; otherwise, budget to bring someone in to do it for you.

Once the build team are on site it is good practice to do some spot checks to make sure that they are following what they have set out in their health and safety plan. If they state that it is a hard-hat site, is everyone wearing a hard hat? Go around every now and again to check on this, and don't be shy to point out anything you see that looks wrong or dangerous, stopping the work if necessary until things are resolved. Cutting corners on health and safety is not something that you can ever condone.

Skills

The on-site work is one of the most intensive parts of the programme for you as PM. Things will (or should) be happening at pace; there are usually a fair number of people working on site; items are being ordered and made off site; there are numerous questions to answer; and you will need to be ready to make quick, clear and firm decisions.

The skills and strengths you will need at this point are:

- Attention to detail: You need to be really familiar with all the drawings so that you understand in detail what is being done on site and how this relates to what the designers intended. The designers will make site visits and will check on what is being produced and provide help, if

needed, on how the details they have specified can be achieved. Make sure to accompany them on their visits whenever you can and ask questions about anything you don't understand. When I started out in exhibition work I was pretty clueless about electrical work, but by continually asking questions I soon built up my knowledge and can now follow a fast-paced on-site discussion about the need for and location of transformers.

- Confidence in your own ability: Admit what you don't know and ask for help.
- Communication: Keep the wider team up to date on what is happening. Your team will want to see what is going on, but remember that building sites, even exhibition sites, can be dangerous, so arrange specific times for a team walk-through, ideally accompanied by the PM. Make sure that people know the rules about being on site, have the correct personal protective equipment and know when they are and aren't allowed on site. Remind them that they cannot issue instructions to the build team and should raise any issues directly with you. Good communication is as essential at this stage of the project as it has been throughout, and I like to produce either a 'look ahead' weekly update for staff, listing what we are planning to happen on site each week, or a weekly project diary with images of work that has been done each week. In this way you can share the progress with the wider team and your colleagues and generate a feeling of ownership and excitement about what is to come.
- Although not really a skill, you will need stamina: Being on site and then going back to the office to complete the paperwork on a daily basis can be very tiring. Keep hydrated and make sure to take breaks.

Signing off the work

A good contractor will ask you to comment on elements of the build as they progress – a lightbox that is finished, an AV installation. This is a good time to be critical, to avoid being left with a really long 'snagging' list at the end of the build. If there is a scuff mark, a bit of paint is missing or a wire isn't as concealed as you had thought it would be, point this out and take a photo of it. This sort of remedying is best done as things go along. Leaving it all to the end could extend the build period and wouldn't do anything to help your relationship with the contractor, who would prefer to get things right as they go along and not be told at the end that you don't like all their paint work! If something you aren't sure about will cost extra, they should tell you – but to be sure about it always take along a set of drawings on your walk round and check that what has been constructed matches them. Obviously, bad

paintwork isn't something you should be charged extra to remedy; but if a cable is visible and you thought it was going to be hidden, check the drawing. If it wasn't specified as running inside a set work you will need to negotiate with the contractor the cost of doing that work and then weigh up whether you think it is worth the cost. Will the visitors notice? Is it worth the extra expense to change it?

Once the work is finished you and the designer should walk through the space together and note down, with accompanying photos if possible, anything that you think has not been finished properly or needs tidying up or fixing. This is your snagging list. You will then need to agree with the contractor which of these are snagging or whether what you are pointing out is a change. It may not be possible to do some of this work immediately and you will need to agree a timetable for its completion and what that may mean in terms of releasing the final payment. A retention should always be built into your payment schedule for the contractor.

Handover

At the end of the build you will need to complete a formal handover, which is when the build contractor hands back the site to the museum and you agree to accept the space back as finished. This is a formal moment in the project and certain things need to happen.

Firstly, you will need all the certificates relating to the build so as to check that the materials used were those agreed (for example, that the fire rating for set works is as you specified) and that all the required approvals have been completed. Some of these will be in the health and safety file, which will contain all the information needed for anyone to carry out any work on site safely, such as changing projector lamps. Other documentation that you receive should include any operating and maintenance manuals, including details of any warranties or guarantees, together with instructions on how to use and clean any set works, AV equipment, lighting etc., testing and commissioning data, such as NICEIC electrical certifications (in the UK) and as-built drawings.

Secondly, you should also receive a pack of any remote controls, fobs, keys and other equipment needed to run the exhibition. The contractor should provide the instruction manuals for these and show you and the front-of-house manager how they work.

Once you have accepted all this information as complete you can take possession of the keys, bid goodbye to the contractor and complete the installation work by installing the objects and final graphics.

Object install

Installing objects is often the last thing to happen in the exhibition build. The objects need to go into a clean space that is protected from temperature changes or vibration. For security, a limited number of people are usually involved in this task, so it is rarely done while the build contractor is still on site. However, if something is so big that it needs to be craned in (Figure 6.2) or a piece of set works has to be carefully constructed around it, there can be the odd exception. For an object-rich display this period of work may need to be broken down into half-day or even hour-long slots to allow for deliveries and installation work. Lenders often like to be on site when their objects are installed, and you need to consider managing them as well as the objects.

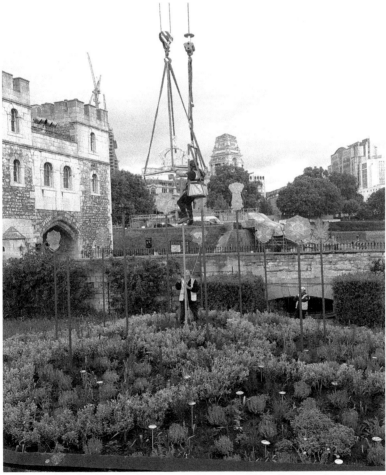

Figure 6.2 *Installation of glass sculptures at the Queen's Garden display at the Tower of London, HRP, as part of Superbloom to celebrate Queen Elizabeth II's Platinum Jubilee* (picture author's own)

Sites are often closed at this point to all but those who are installing pieces and, perhaps, the lighting designer, who will need to focus the lights. Make sure that you have an up-to-date list of who is doing what and that you can control access to the space. This can be an anxious time, as mounts and cases designed in advance based on object details may sometimes prove not to work as expected, couriers can be delayed and condition checks before the objects are installed can reveal problems that haven't been considered. Plan plenty of time for this period of work and have people available who can adjust mounts and solve installation problems quickly and calmly. You may also need to schedule time for some professional photography of the objects between their arrival and installation. Have you booked the right people and do they have the appropriate security clearances?

Seeing the objects going in is one of my favourite parts of the exhibition installation. This is the moment when all the hard work seems worth it as the curators and interpretation team arrange the cases and the lighting designer works to focus the lighting so as to make the best of the pieces that have been chosen. Once the objects are in, it is much more difficult to work in the space, so before you start make sure that everything else is finished that can be.

Gateway moment

Now that the exhibition is installed you arrive at the next (third) gateway moment for the project, following which, the project will move from the execution to the transition stage. At this moment you will be asking: 'Has the exhibition been installed as per the designs? Is everything finished to a satisfactory and safe standard?' If you are satisfied that the exhibition is as complete as it can be (other than any minor snagging) and is ready for handover to the operational team, you will now move to the transition stage of the project. You usually take your project board or senior management team around the display at this time to check there isn't anything that they weren't expecting, although you need to be clear with them that this isn't really the time to be requesting changes but it is the moment they sign off the exhibition as ready for handover.

Box 6.2: De-installation

For temporary exhibitions you may need to return to the project and oversee its removal from site. Although you will have passed through the fourth gateway of handover you will not complete your evaluation of the project until it is de-installed. For de-installation you will need to consider all the issues around being on site that are covered in Chapter 6, space to decant and pack objects, what Health and Safety regulations apply such as CDM in the UK and security. You will probably need to work with your team again to draw up a mini-programme showing who will be on site when and what they will be doing. Taking an exhibition out never takes as long as putting it in but needs to be planned carefully so that objects are safely removed and returned and any set works, graphic, lighting, AV, showcases, etc. can be saved for the future, recycled or given away as appropriate.

Let's summarise

In summary, the work you need to do during installation of the exhibition consists of:

- preparing the site for the installation work. Think about the spaces needed for all the surrounding tasks and the routes that the contractors will take in and out of the building;
- sequencing the work so that you have time at the end of the build for object installation;
- managing health and safety on site and understanding the importance of your role in ensuring that the designers and contractors have planned how to minimise risk on site during installation and for the public afterwards. If you do nothing else, having read this chapter, familiarise yourself with your responsibilities in this area. In the UK this means having a thorough understanding of the CDM Regulations;
- being present on site and running a clear change control procedure;
- signing off work by the contractor and agreeing what snagging needs to be done;
- managing the handover from contractor to client;
- planning and managing the object installation period.

TRANSITION

In Part 4 we will look at the work that needs to happen once the exhibition is fully installed. Although you may think your work is done, some crucial tasks need to be completed that will contribute to the success of the project. Don't celebrate just yet . . .

Preparing for Opening

Introduction

You have said goodbye to the build contractor, all the objects are in their cases, the site is tidy and clean and you have passed the gateway moment of getting approval that you can hand over the site to the operational team. But this isn't the end of your work. Preparing for opening starts before and continues during the build and installation work and needs to be planned for and monitored just like every other part of the exhibition process. What does getting ready for opening look like, and what tasks do you, the PM, need to plan for?

For an exhibition to be successful not only does it need to look good and be informative and relevant; it also needs to be integrated into the museum experience and communicated to the public at large. This chapter looks at some of the tasks you will need to undertake alongside and immediately following the physical construction of the space.

Communication

No matter how wonderful the exhibition is, it won't mean anything if people don't know about it. The project plan needs to include time, space and, if it is to be included in the exhibition budget, money for marketing and public relations (PR) activities. Your communication could be as simple as updating the museum's website or as complex as a full marketing and PR strategy. Whichever route the museum takes, the delivery of this work needs to be monitored and included in the project plan. Even if the museum has a separate marketing or PR department, it will still need information from the project team at key moments, and this could take your team by surprise or divert them from on-site project work at a crucial time if they are not prepared for it.

Early on in the project, when you are putting together the project plan, you should discuss the needs of project and marketing/PR teams and build in time

for the curators to write or edit copy for the website, books or social content, making sure that the deadlines for these elements don't clash with key dates for writing or reviewing exhibition text.

Any marketing or press work will probably require photography of star objects and images of the exhibition in its finished but unopened state, ready for launch day. Quite often for a larger exhibition you will need to set aside a day or maybe longer for the press to visit, interview curators and take photos. As PM you will need to be on hand to show off the space, smoothly switching on and off lights, AV and anything else as required. If there is to be any filming the crew may want a soundscape turned off or the lighting to be in a different configuration than it would be for the visiting public. (At the handover from the contractor you will have made sure that you and the front-of-house manager are familiar with how everything works.)

In thinking about opening, it is a good idea to put yourself in your visitors' shoes and consider what questions they may ask about the exhibition. Talk to the staff who answer the phones or work with social media, and with them and the project team create a list of answers to what you think may be frequently asked questions. This will save a lot of time when you open, as those dealing with visitor enquiries will have the answers at their fingertips.

Wider museum changes

An exhibition or new display in one area of the museum will have knock-on effects elsewhere. These could be changes in ticket prices if the display is included in the price; or changes to signage may be needed to help visitors find the exhibition, or an update of a map. Make sure that you have worked out what all these changes will be and that someone on your team is responsible for making them happen at the right time. Changes to signage can be done in advance, with 'coming soon' stickers or flashes that can be removed on opening day; alternatively, you can install the signage on the evening before opening (but this will put the pressure on, and can lead to a very late night!).

Website changes need to be prepared in advance and ready to go live either on the date when you announce the exhibition to the press or on the day that tickets go on sale. The front-of-house team will want outline information so that they can start telling visitors about what is coming up and how, if they need to, they can book in.

If you think that the exhibition is going to drive up visitors numbers significantly, do the café know about this and have they planned to have extra staff on hand and plenty of stock in place? Will they create anything themed around the exhibition, such as tray inserts or table centres that reflect the look

and feel of the show? What about retail? The museum shop will have been part of your wider team, and so they will have been preparing stock related to the exhibition for some time, but are they ready and have they planned in time to dress all or part of the shop to reflect the opening? Does the shop need to be ready and open for any pre-opening events such a members' day or for an opening evening event?

As is the case with most tasks that are related to preparing an exhibition, these tasks will fall to others and not to you, but your role as PM will be to make sure that all these people know the key dates in the programme, that they have set aside time and budget to make these things happen and that they are doing what they said they would at the time when it should be done. You will need to have a clear list of all these extra activities, to know when to follow up on them and to work out what you will do if anything slips behind schedule. Is there a department manager to whom you can talk to about your concerns? Will you report an issue to the project board, or should it go further up to the museum director? You will need to make sure that relevant department managers have the dates marked as a priority in their calendars at an early stage (see Chapter 2), and to check in with them regularly.

Front of house

You can't expect the front-of-house staff to walk in on the first day of public opening and run the exhibition. You will need to plan for and work on a series of tasks to hand over the space from the project team to the business-as-usual team. With this handover to the operations side of the museum the project will come to an end, as will your responsibilities as PM for the space.

As described in previous chapters, you will have been keeping the front-of-house team up to date and involved in the design and production of the exhibition from the very beginning, having a representative from that team on your core team and providing regular opportunities for them to see developments via presentations, written updates and site visits.

You should plan for one or two days, once the exhibition is ready, for everyone who is going to work in the space to come in and experience the exhibition, read the labels and text and spend some time getting to know the space. For team leaders or those who will be in the space more often, you should arrange for the curator and/or the interpretation specialist to give a tour so that they can build up their knowledge on the subject and be ready to answer visitors' questions. It is also a good idea to provide the operations team with an information pack about the display. The curators or interpretation team can put this together. Aileen Peirce, head of interpretation and design at Historic Royal Palaces, suggests that you include:

- a brief introduction (the project vision; approximately 200 words);
- any obvious big why/when/who/where/how questions; e.g. who used these rooms? Why have we represented them like this? When did they live here?
- biographies of key characters (maximum 400 words);
- a timeline and/or family tree, if relevant to the subject matter;
- a brief outline of the overall design approach and any key elements; e.g. if a visitor asks 'what's the background music?', 'why are the banners red?', 'why did you choose that pattern?', 'how did you make the furniture?', it will be explained briefly in the information pack;
- a room-by-room guide with key messages, plus brief answers to any frequent questions;
- object photos, label text and a little further information that didn't make it into the labels but might be interesting;
- information sources. Sometimes visitors ask 'how do you know this?' – and front-of-house teams are often interested in this too – so the information pack might mention the key archival/visual/material sources that have been used as evidence and include pictures of some of them;
- a short list of further reading in case the front-of-house team want to read more or a visitor asks for a reading recommendation.

Share a draft of the information pack with the front-of-house team and check with them that it covers everything they need to know and in a useful format. It is never too late to improve it! Check with them again a week or so after opening, as they may be being asked questions which no one had anticipated. This may mean revising a label or room graphic to meet the need, but in the meantime you can update the front-of-house information pack so that the team are armed with the answers they need.

Equipment operation

You will also need to provide training on the daily start-up and shut-down of the exhibition for those staff who will be responsible for this. The contractor will have taken you through this and given you the manuals that go with any equipment. I find that it's best to turn this information into a series of laminated sheets that can be kept in a box or folder together with any remote controls. These sheets should show images of switches, remote controls or control panels, with clear annotations as to which buttons do what and the order in which things should be turned on or off. If necessary, include a note saying how long it takes for something to come to life after switching the 'on' button, as many have a disconcerting delay! In this pack you should also

include troubleshooting information in case something doesn't work, and details of any call-out agreements you have put in place, so that whoever is on duty knows what number to call if something stops working.

Cleaning

The cleaning team will need to have information about how to clean the exhibition, as some set works might need specialist cleaning materials. If the wrong equipment or cleaning agents are used, this could invalidate the warranties. The maintenance team, if the museum has one, will also need information on what everything is made from and its care. Things like the type of light bulbs in the fittings or the make of projectors and how to source parts should all form part of the information you prepare for handover. Most of this information will be in the operating and health and safety manual handed to you by the contractor, so make sure this is handed over and is fully understood by those who will be caring for the space. It might be that you hand a complete copy to the maintenance team but provide summaries for ready reference to other teams or key members of staff, as the full manual can sometimes be rather impenetrable. Spending a bit of time putting together clear information to hand over to others is invaluable, and will avoid those 8:00 a.m. Sunday morning phone calls to your mobile when someone finds that something won't switch on.

Members, supporters and friends

The museum may have a friends or members group, or even a group of local stakeholders or donors, whom you want to invite to view the exhibition before it opens to the public proper. This is a great time to test that everything is working as it should, so plan for a day to open for these guests. If you invite members and friends, let them know that this is a preview and that you are testing the event on them, so that they will be understanding if things don't run quite as smoothly as one would expect. Most groups really enjoy having a preview and will be happy to give you some feedback. Ask them to tell you about their experience, as these will be your first visitors from outside the museum to experience the finished exhibition. By watching, and asking them questions, you can establish if the seats are in the right place, whether the staff were able to answer their questions, how they found the lighting levels, whether the sound was right, how they enjoyed the experience and what they liked best. You may find that you can't do anything about some of their responses, but for others you can put remedies in place before the general public start visiting. Invariably, someone will spot a mistake on a label,

perhaps a date that isn't quite right or a spelling mistake, despite the fact that these were read and proofread for what seemed like hundreds of times!

Thanking the team

This pre-opening moment is also when you can thank the team for all their hard work. Such an event always goes down well and it is important that you, as PM, invite and thank the right people. In some larger museums you may have a gala or red carpet event where important supporters and sponsors of the museum, along with key journalists, influencers and celebrities, are invited to see the show before opening. If this is the case in your institution, it is important that you either negotiate for your team to attend or reserve some budget for a smaller, lower-key event or gifts for the project team that shows that the museum recognises their hard work to complete the project. Producing an exhibition is hard work, and a moment of celebration when it is all finally done helps to make all the long hours seem more worth it.

Troubleshooting

As a PM you shouldn't abandon the project as soon as it is handed over to your operational colleagues. I sometimes joke that I build and walk away, but this isn't actually true. I think it is important that you are there on the floor and visible for the first few days of opening, on hand to help with any teething problems, and are available regularly throughout the run, watching for any areas of concern. You don't need to stand on the gallery floor all day, but being there when the first visitors come in is a lovely moment and it is good to share it with the team on site. Being approachable and accessible while the team get to know the space can really help to build their support for the next time you disrupt the museum with a new installation. You will be surprised to find how many minor problems you can solve for the operational team just by being close by and having watched the installation take place. Whether it's knowing the sequence in which to turn on the lights or how to secure a door open, your expertise will be useful to the team and it will be reassuring for them to know that if something unexpected should happen with any of the equipment you are on hand to take them through the troubleshooting or call-out procedures. I often move to another site once an exhibition or project is finished, but I make a point of basing myself in the building where I have last had a project about once a month and going round to check that everything is still all right. You should never build and walk away!

Gateway moment

Opening day is another gateway moment, your fourth. Although you may have some snagging to complete out of hours, the work to produce the exhibition is finished and your role in leading it on site is over. At this moment you will be asking: 'Is the exhibition ready for the visitors to use?' You will need to have sign off from your project board or senior managers that they agree it is safe and ready. If you are satisfied that everything is in place for the front-of-house staff to run the exhibition and help visitors to enjoy a great experience, you will now move to the project closure stage.

Let's summarise

In this chapter we have discussed the importance of that small window between finishing the installation of the exhibition and the opening day. This is when you:

- hand over information to the operational teams on how the exhibition works and how to care for it;
- carry out staff training and familiarisation with the exhibition, providing information packs on how things work, additional information to supplement their knowledge and answers to what you think may be frequently asked questions;
- ensure that all the wrap-around supporting elements in the shop, café and signage are in place;
- hold events to test the running of the exhibition and to show off the exhibition to any important stakeholders, including your project board and senior management team or the press;
- thank the teams who helped to make the project a reality and celebrate all the hard work that went into creating the exhibition.

PART 5

EVALUATING THE PROJECT

The contractor has finished on site, you have held staff training days and opening events. Now that the public are enjoying the exhibition you have passed from the transition stage to the evaluation stage and are no longer working on site. But there is still work that you, as PM, need to do to close the project and make sure that any lessons learned are recorded and passed on to improve practice for next time. This is the moment in the project when it might be easy to think that it's all over, but some key tasks are needed to close it down and evaluate how it has gone.

Project Closure

Introduction

This chapter will look at some of the work needed at the end of the project to bring it to a close and leave the paperwork tidy and well ordered for future reference. We will also look at how the project should be evaluated and how the feedback can be used and incorporated in your future work as a PM running successful exhibition projects.

Finances

One of the first things you will need to ensure once the exhibition is open is that all of the contractors and consultants have been paid. Throughout the project you should have been keeping your cost plan up to date (see Chapter 10). Now is the time to go back over the plan and tidy up.

Check that all the purchase orders you raised have been recorded and, with your finance team or specialist, record what has already been paid out (ideally you will have been reconciling this monthly, but it never hurts to do a double check at this stage). Deal with any outstanding payments and invoices. You will probably want to chase up outstanding invoices, as it is best to get as much finished now as you can, so that you can record the project as financially complete once everything has been paid out. If you have installed a temporary exhibition, check that you have the budget reserved for the de-install and that your finance team is aware that the project will not be closed until after you have completed that process; this may mean that the project stretches across another financial year.

For longer-term installations or exhibitions you may need to record some of the assets that have been bought or created for the exhibition as 'fixed assets', which become part of the museum's list of equipment or holdings that are unlikely to be sold off or disposed of within the coming year. Fixed assets

are often reported as a line in formal financial end-of-year accounts, so consult with your finance officer or team about whether this is necessary.

Report to your finance team any retentions or payments that you have agreed that will be held until later, so that they can plan for this money to leave the museum's accounts at the right time. You may have been asked to create a cash flow forecast earlier in the project. If that was the case, check whether any items are still outstanding that you expected to have been paid earlier, and follow these up.

You will also need to produce a report for your project board or senior management team. Did the expenditure go as planned? If you were over budget (or more rarely under budget) how does this affect the predicted business case? Do the Project Board agree that the project is finished or are there elements they still want to see delivered or that they feel need more work?

Handover

At the time of the formal handover from the contractor you will have agreed that they had completed all the work on the contract. This is a formal moment in the life of the contract where you accept, often in writing, that the work is complete and satisfactory. This then allows the final payments to be made. If you are running a temporary show with the contractor coming back to help you strip out the exhibition, the closure of the contract will come later. If you are holding a retention again the closure will come later – but hopefully, by that stage, it will be a mere formality.

At the handover you will have created a list of any outstanding pieces of work that need to be completed and will have agreed with the contractor how and when they will be done. This is known as the snagging or punch list. If this list is long and complex the contractor will need to continue working until it has been completed or has reached a stage where they can be stood down. Hopefully, because you have been monitoring the work throughout and discussing issues with your contractor regularly, this list won't be too long or complex. If you are lucky enough to have a procurement department, they will have a process for you to follow to close off the contract and agree completion.

Files

Now is also the time to tidy up the project files. Often in the push towards opening it's easy to let file maintenance slip, but you need to leave a clear and well-ordered record of how the project was run, of key decisions that were made, of who worked on what and how the design developed.

Make sure that final signed copies of any documents that have a legal standing, such as contracts, are filed logically. Review all the key project documents and make sure that they are up to date. Finalise the risk register and make sure that the programme and cost plan reflect all changes that were made as the project progressed. You will also need to ensure that the decision register is clear and accessible. It should have clear links to the evidence that shows the progress of the project through the decisions that were made (for more on the decision register see Chapter 2).

Having a standard filing system for projects, with the folders for each exhibition always named in the same style and arranged in the same order, will help future team members to locate key information. Dating your documents will help with version control. Get to know and understand your museum's records retention policy and mark up those records that need to be kept for a longer period. Weed out any duplicate documents or drafts (unless you need a record to show how an element of the project developed or changed) and, if necessary, print and file paper copies of those documents that will go into archival storage.

Move all the final artwork, design files, sound files, films and any other content that you have created into a folder or place that is easily accessible for your colleagues and successors, so that if any content needs to be updated in the future people will be able to find and access it easily. Nothing is worse than needing to do an object rotation or correction and not being able to find the final label template easily!

Process review

As you go through the files, review your early assumptions about the project and make notes on the differences between what you thought would happen and what actually happened. Areas to focus on will include your early cost estimates and income predictions, and how close these were to the predictions you submitted with your project definition and to your initial, more detailed budget. How did the cost per square metre measure up to previous exhibitions? Did anything of note happen that led to changes that you want to record so that anyone looking back can understand these changes in context?

How about the programme? Did you and the team stick to the initial time frames for each element of the project, or did you have to adapt them as you went along (you usually do have to make some adaptations, so don't beat yourself up over this!). If you did make changes, why was this, and does it mean that you will change your base programme next time?

Also study your risk register. What things came up that you weren't expecting? Based on issues that did come up, would you add new risks to

your next risk register? What risks did you spend time on ensuring were mitigated, and was anything perceived as a great risk that didn't eventuate? Again, consider how this may affect how you rate similar risks and manage issues in the future.

Take some time to reflect on the decision-making process. Did it work, and was the process smooth? Do you need to alter the amount of time that you spend communicating decisions, or do you need to open up some decisions for more democratic discussion? Conversely, would having a more formal means of sign-off benefit your next project? Did the RACI work, were people clear about who was doing what and did they stick to it? What adaptions needed to be made, and why?

Record all these learnings in a document that will become your internal evaluation report, and add in the team's thoughts as to how the project went. This summary can then be picked up by others managing projects or used again by you ready for next time.

Learning lessons from the project

Learning lessons from a project is key for any PM and project team, but doing it in a way that doesn't start a blame culture is a skill that needs to be learned.

One of the best ways I have found to gather lessons learned and discuss them openly without assigning blame is to survey the team and then hold a review meeting. Like any evaluation and facilitated discussion, this will take some time and planning, and it should be allowed for in your workload. It is important that, as a PM, you don't get swept straight into another project immediately after the one you have been working on closes. You will need some time to complete the project closure activities and the running and analysis of the review.

Surveying the team

The first thing I like to do at the end of a project is to survey the team and gather their thoughts on what went well, what could have been done better or what went wrong and why. It is a good idea to do this quite soon after the exhibition has opened (even if it is a temporary one) so that views are fresh and people haven't forgotten what has happened. For a temporary exhibition this process could be completed again after the closure and de-install. You could begin by either holding short interviews with the key team members to see what they say or asking them to fill in a short form. From my experience, a form can work better than an interview, as some of what team members want to discuss may be about your own performance or that of

others on the team, and doing that face to face may be difficult. If the project has been somewhat fraught you may be inclined to allow the team to provide feedback anonymously, either sending out a form and asking team members to print out their answers and drop them in a box or using a tool like Survey Monkey and omitting personal details. However, I do think that it is better if you know where the answers are coming from, as this will help you to analyse them and judge if they are something that needs to be addressed, and how.

For example, an anonymous comment that text production was difficult and could be done differently would be hard to get to the bottom of without going back and questioning all those involved more closely. But if you know that the comment came from the interpretation manager, whose time for editing you know was limited because the curator couldn't finish the text to deadline because they were also being pressured by the publications department for book text, then you can easily note that the lessons learned are about clearer communication as to why text deadlines are important and working more closely with the publications team to ensure that deadlines don't clash.

For the review process to work, you will need to have fostered a no-blame culture throughout the project. If you haven't, then it is likely that team members will be reluctant to reveal problems and may even try to hide where things have gone wrong, for fear that they will suffer consequences for revealing this.

It is important on your survey form to ask not just for details of what went wrong or things that can be improved, but also for what went well and what the team enjoyed about the project. The review should also be a celebration of what you have all achieved together – you want to end the project on a high note!

Once you have received all the forms from the project team you will need to spend some time analysing them. Be prepared to take some criticism, as no PM is perfect and there will always be areas where you can improve. The review should not be used by people to attack other team members personally, so make it very clear in your communication about the review that this is all about project process. If you do receive feedback which centres on the behaviour of an individual, it is best to follow this up privately with those involved. Handle it sensitively and, if you need to, involve line managers, as this process can sometimes reveal issues related to performance management as well as project process.

As you review the information from the forms, look for any common themes. There are usually a few key areas that most of your team will refer to and that shouldn't come as a surprise to you. You should base the agenda for your review meeting on these.

Create depersonalised summaries of the key themes and prepare for a discussion that looks forward to how processes and procedures can be improved in the future to help prevent the same issues arising again. Take time before the meeting to think about how you might divide the team into smaller groups to discuss these issues – you won't want to place people in the same group who may have had difficulties in working together; or you may want to divide the team into groups so that specific issues are discussed by those who were actually involved.

For larger projects or ones that have been difficult it may be worth bringing in someone neutral to run the review process. This can be another member of senior staff from the museum, or even an external facilitator who can also summarise the findings into a report for you. This can defuse difficult situations and allow you more time to reflect on your own practice and the project's development.

The review meeting

I like to create an agenda which starts off with a summary of the project, looks at the objectives that were set and leads into a discussion about how well these were met. Ideally, I would divide the team into smaller groups and ask them to reflect on a particular or small number of objectives and feed back their feelings on this to the larger group. You might want to run more than one of these meetings, gathering feedback from the project team, the senior managers or project board. Note taking is very important, as you will want to capture the project team's feedback. It is a good idea to set some ground rules at the beginning of the meeting, reminding participants that:

- the session is about continuous improvement;
- discussions should be based on facts, not opinions;
- it is not about assigning blame or singling out individuals;
- the focus is on how risks, changes and issues were handled;
- it is about improving process and communication for the next time.

After a discussion about the objectives you can move on to your analysis of the feedback. After discussing the feedback on areas for improvement you can wrap up the meeting with a more upbeat discussion about the things that went well and celebrate the successes of the project. This is a nice way to end the session, allowing everyone to feel that they have contributed to something positive and that they are all recognised and celebrated for their part in it. You may want to end the process with refreshments or by distributing rewards!

Putting recommendations into action

After the review meeting you will need to turn the feedback, ideas and discussion points into a report which should summarise the key findings and note any areas where the museum's processes need to be adapted to promote further success in the future. Writing the report isn't the end of this work, as a report on its own won't bring about change; what will, is if your recommendations are built into your project methodologies and are acknowledged and engaged with by the project team, senior managers and, if need be, the museum's trustees.

So, your next job is to clearly articulate the main changes that should be made and to engage those working on projects with the process of change that needs to take place. This means that you will need to become the lead advocate for the recommendations and remind your museum colleagues of the changes that they have signed up to.

These key findings from your review should be saved not only in your project files but also more centrally, in a space that is easily accessible and regularly updated. The organisation's intranet, if it has one, is a good hub for this.

It may be that you will need to review some of the museum's project management procedures and that this change is something that can't be implemented quickly. If this is the case, it is a good idea to change the recommendations into an action plan that can be monitored by your project board, senior manager or even your trustees, perhaps via a quarterly report on progress. At the start of each new project make it part of your practice to look back at previous reports to remind yourself of the main issues faced in each project so you can take steps early on to mitigate against them.

Evaluating exhibition success

Your evaluation of the success of the project must include not only an internal review of how the project went but also an evaluation of its reception by stakeholders and, of course, the visitors. In Chapter 1 we discussed how to plan SMART objectives for the project, creating tangible targets against which to measure it. Now is the time to evaluate these targets for their success. You will have built into your programme and budgets the time and money (if needed) to carry out this work. If you engage an external company or a freelancer to carry out the evaluation, you will need to write a clear brief for them, describing what you want to measure and what your baselines are. If you do the work in house, think carefully about the questions and methods you use to track success and who will take on the time-consuming work of analysing and interpreting the data that is collected.

See Chapter 2 for more about the methods that you can adopt for in-house evaluation, and I urge you to do more research to keep up to date with emerging techniques. In the UK a good place to start is with looking at the work of the Visitor Studies Group (www.visitors.org.uk).

There are many different routes to evaluating an exhibition, from looking at learning outcomes to evaluating social change. As part of your project definition (see Chapter 1) you should have identified which elements were important to you and how you would measure them. There are different ways of doing this measurement, including using evaluation frameworks like Morris, Hargreaves and McIntyre's model of visitor behaviour (see Online resources), which, by tracking visitors' movements in a gallery, starts to identify how visitors select and therefore make meanings from objects. The model then goes on to assign a depth-of-engagement rating to each behaviour, encouraging museums to consider how to move visitors along a scale from being browsers to following, searching and ultimately researching in the space. Beverley Serrell takes a different approach, proposing that exhibitions are judged against four criteria: Comfortable, Engaging, Reinforcing and Meaningful, with each criterion being further broken down into a series of tangible aspects which those judging the exhibition can rate (Serrell, 2006). Whatever route you take, it is worth remembering that, as the *Evaluation Toolkit for Museum Practitioners* (Forster, 2008) states, 'It is not advisable to use an existing template for any evaluation if it does not ask the questions you would like answered' (Forster, 2008, 6).

As with the results from the internal review, the evaluation should provide not just information on the success of the exhibition but also analysis and recommendations for how future projects could be adapted for greater success. For example, if your original plan was for the exhibition to attract more families and the results show that it wasn't as successful as you hoped in reaching your targets, you will need to consider and include recommendations on what could have been done differently to improve this. As with most project tasks, this isn't an analysis that you can do alone, and it will need to be done with the whole project team. Unlike the review meeting – which should take place as soon as possible after the project is finished – this work necessarily has to take place later, as you will need time to gather data from visitors.

If a project was designed to also act as a catalyst for change within the museum – for example, introducing a change in the way the front-of-house team work – you may want to hold two review meetings: one soon after the exhibition has opened and one later on in the exhibition run to evaluate how the changes are embedding, as well as to look at visitor feedback. Again, the results will need to be disseminated and the lessons learned from them

extracted, agreed on and any action plans developed. As with the review lessons, it is a good idea to keep evaluation reports centrally and accessible to a wide range of staff.

Continuous improvement

With both reports it is worth doing a yearly (or as regularly as you think is necessary, depending on the rate of exhibition turn rounds) summary of all the findings to see if there are some common themes that continue to come up. If this is the case, a deeper or even a cultural change may be needed to tackle them. This is something that would need to be taken forward by senior managers in the museum.

If you follow this process of continuing improvement you will see each project that you run become smoother and easier to manage as you and the teams you work with fall into the pattern of running these kinds of project. But don't let this mean that you fall into the trap of complacency or start turning out exhibitions that are all very similar. It can be a good idea to shake things up by bringing in external colleagues and asking them to critique your work and provide you and the team with feedback on the exhibitions. You may be surprised at the advice and comments they provide. Keep up to date with developments in project management, because new practice and ideas on how to best manage risk, cost, quality and programme are often introduced as organisations such as the Association of Project Managers and RIBA update their best practice guides and plans of work.

Sustainability, accessibility and inclusivity

As discussed in previous chapters, you will have been monitoring and making decisions about the sustainability, accessibility and inclusivity of the project throughout its development. Now is the time to summarise this work and evaluate its effectiveness. Look back through the goals you set and the decisions you made. Hopefully, you will have kept a clear record of why you decided on a particular course of action. You may want to include a section on each of these areas (or those that were relevant to the project) in your internal review report, illustrating where the project was most effective in meeting the goals that were set. Analyse the work that you did throughout the project and compare this to the goals that you set. As with all your other evaluation work, disseminate the findings and create action plans to improve future practice. It is important for these elements of the project that you keep a register of work that you chose to do and any decisions you made and why, especially if you were unable to meet a goal or implement a recommendation.

This can help if you are questioned as to why an element was not included, or it can be used as an additional good news story if you have been successful in incorporating a new way of working into your project.

Gateway moment

This is the last gateway in your project. You have officially finished! At this gateway you will present your final financial summary, information about whether the project met its objectives and the lessons that can be learned for the future to your Project Board or senior management team.

At this moment you will be asking: 'How well did the exhibition perform against its targets? What lessons have we learned for the future?'

Let's summarise

In this chapter we have looked at the main tasks that need to be completed once an exhibition is open in order for the project to be brought to a neat and tidy close. These tasks are:

- closing out the finances and ensuring that all the records relating to this are up to date and, once everything is financially complete, reporting on any equipment or holdings which should be transferred to the museum's fixed assets register;
- tidying up the project files, leaving a clear record of the project development, contracts, design development and decisions, and identifying those documents that need to be kept as part of the museum's records retention policy;
- holding a review session with your team including your Project Board or senior managers recording and acting on the results;
- evaluating the exhibition from a number of different angles, including visitor feedback, sustainability, accessibility and inclusivity, and recording the results to inform future actions;
- using the findings from the closure period to improve your own practice in your next project;
- getting approval from your Project Board or senior management team that they agree the project has finished and that they endorse and support your recommendations and evaluation of the project.

PART 6

KEY PROJECT MANAGEMENT SKILLS

Part 6 deals with the key skills needed to successfully run a project: managing time, risk and money. This is work that you will have been doing all the way through the process outlined in the preceding parts of this book.

How to Manage a Project Programme

Introduction

In this chapter we will discuss how, once you have set up your programme (see Chapter 2), you will manage it throughout the project. We will look at how keeping an eye on the project and the cost plan together can help you form a picture of how the overall project is progressing and how communication will help you to keep on track. Much of programme and project management is about honing your leadership skills, and we will explore some of those skills in this chapter.

How to manage the programme

Chapter 2 discussed the mechanics of how to set up a project timeline or programme. But there is much more to your role as PM than just this: you must actively manage the programme – it won't just happen because you have written it down, and it is quite likely to change as you progress through the journey of exhibition design and your and your team's ideas about the exhibition change. So, how do you do this?

You need to know your programme well, to make sure that you understand it and to remember why you put things in the order that you did and what decisions you reached about the allocation of the work. If necessary, keep notes so that if you do change things later you can be clear about the impact this may have on your earlier assumptions. It is a good idea to keep a record of each iteration of your programme, so that if it does change you can track where the changes were made and why. This will help you to spot any problem team members or any areas of the project that are not as straightforward as you had imagined – and it will help you on your next project, as perhaps you under- or overestimated the time certain tasks would take. Take a regular look at your programme and be honest about how well you and the team are meeting the deadlines that you set. Don't be afraid to

work with the team to adjust the programme if this becomes necessary; but also try not to make a habit of this, as the programme should be as static as possible and the team will only become confused and not respect deadlines if they are constantly changing.

It is always a good idea, if you can, to build a bit of slack into the timeline. You could put it in as contingency time, or perhaps just extend a few key tasks a little – for example, leaving a few days or a week at the end of each design stage to allow for the unexpected. In that way if you find, for example, that loan agreements are taking longer than expected, then you can adapt the programme to accommodate this. I generally build in some slack if I can, but I am not really open about it or where in the timeline it sits, because if the team start to think the deadlines aren't real or important you can find yourself in a tricky situation!

Communication

Perhaps more importantly, you need to establish really good communication with your team. You need to be able to explain the deadlines and dependencies of the programme to the team and hold them to account for completing their tasks. They need to be crystal clear about what is expected of them and by when. Some of this will come from an understanding of the programme and some of it will come from the RACI (see Chapter 2). This will mean regular communication and discussion about progress. If you are new to project management or haven't had much experience in line management this can feel rather daunting, but you need to be able to hold people to account for completing the work they have taken on and the project will run so much more smoothly if you have the confidence to question people about the work they are doing and their ability to meet the deadlines set. Those working on the exhibition will very likely also be involved in other work, and, if this is the case, you will need to make sure that they and their line managers agree to the deadlines they have been set for the project. If they are given extra work to complete, you will need to go back to their managers to remind them of what they had agreed earlier.

You will need to check in with staff regularly, either through team meetings or through one-to-one conversations, and to listen carefully and drill down to see if there are any hidden worries about completing the work. Try to free up conversation by using open questions that don't require yes or no answers and that encourage dialogue. Don't hesitate to ask to see work in progress or to offer help if someone is finding something difficult.

Watch out for perfectionism. This may sound odd, but getting that text just right, spending extra time trying to locate that perfect light fitting or having

just one more week of research in the archives can be just as dangerous to the project plan as someone not writing the text at all. If someone is a perfectionist, that is a positive, because it means that they will be fully committed to getting the exhibition just right; but they may also need some coaching to let go of small things so as not to delay decisions that are time critical.

There will also be team members who 'forget' the implications of making changes after the designs have been signed off. Again, these will usually be team members who are heavily invested in the project and really want it to be the best it can be; but late changes cause increases in cost and can endanger the programme, so make sure at the outset of the work to clearly explain what sign-off means and that if further changes are proposed they must go through a rigorous review that includes cost and time implications before they are agreed.

If you are working to very tight deadlines then you will need to negotiate with staff about overtime, or try to come up with creative ways to get things done. And done it can be! I have worked on exhibitions where, due to circumstances beyond anyone's control, half the content changed during detailed design, or when the opening date had to be brought forward by a week to accommodate an unexpected event. It wasn't easy, but by having good lines of communication and a team committed to the work we were able to make it happen. However, just because you can pull the rabbit out of the hat for an unexpected event, this doesn't mean that you should make a habit of it. Projects need to be managed well, and pushing people to deliver under stress isn't something that should be considered lightly.

Leadership

For you as the PM it is all right not to know all the answers and to tell those whom you are managing that you will need to get back to them, but what you must do is demonstrate leadership and inspire confidence in the team. If you display confidence that something can be done and it will work, that often means that it will, as the team will follow your lead. But be careful, don't be over-optimistic, and always take time to think about what you are being asked to do and whether it is really possible to achieve. An optimism bias on a team can be just as dangerous as someone not meeting crucial deadlines. Sometimes you will need to say 'no' to a deadline extension or a change, but make it clear why: If the deadline is missed the exhibition won't open on time, or it will cost £X more to complete. People will be much more accommodating if they know the reasons behind your thinking. If things are looking problematic, don't keep it to yourself but ask others to help and raise it with

your superiors. There may be ways round a problem that you cannot see or are not in a position to influence on your own.

In many ways, project management is similar to line management: you will be delegating tasks, setting work programmes and keeping in touch with your team. Try to create a working environment that allows the project team members to come together and get to know each other: they need to be able to form a team who collectively feel responsible for completing the project, feel valued and have a way of communicating that is open and transparent. Your role is to facilitate this and encourage the team to tackle the risks and issues that will inevitably come up, as well as to celebrate the project's successes as it develops.

Let's summarise

In this chapter we have looked at the skills required to manage a programme such as:

- keeping a record of the iterations of your programme so that you can analyse for patterns and improve your programming skills;
- communicating well with the project team and knowing when to push for a goal and when to ask for help;
- knowing how to leave yourself a bit of contingency time for unexpected changes;
- understanding your role in ensuring that everyone is aware of the work they need to complete and the effect that missed deadlines can have on project completion;
- practising your leadership skills.

CHAPTER 10

Setting and Managing a Budget

Introduction

Along with programme and overall quality, managing the cost of the project is one of the main roles of a PM. A good PM should keep an eye on the amount that is being expended at all times, and this often means that you have to look at both the big picture and the granular detail. This is not easy, but is a skill that can be learned, and the more projects you complete, the easier it will get. The best way of tackling budget management is to take a systematic approach to what you are doing and to use the expertise of those around you to estimate costs and keep a tab on what is going on. Every museum will have its own financial systems, so, rather than going into detail about the mechanics of ordering goods or invoice management, this chapter is about how to keep a tab on the costs. We will look at the importance of valuing the work completed so as to help you judge if you are on track, and the chapter provides some suggestions on how to set up a cost plan so that you will have all the right information in an easy-to-access format that, once set up, can be used again and again over subsequent projects.

Understand your finances

Before you can start effectively managing your budget it is essential to understand how your own museum's budgets work and how you will be expected to manage and report on any budgets that are delegated to you. Each museum is different in how it assigns funds, often depending on its size and the regularity with which it puts on new exhibitions and shows. Before you start you will need to know what your exhibition budget is expected to cover. Is it the fees and costs solely related to producing the exhibition itself, or are you also required to fund the marketing of the exhibition and any material produced about it, such as a catalogue or booklet? Will you need to account for materials for schools, and what about any supporting

programmes such as family workshops or lectures on the subject? Make sure that everyone is clear about what is included and what is being accounted for elsewhere, otherwise you may come unstuck if you are presented with a cost, such as updating the website, that you didn't realise you were responsible for.

You will also need to know how any income will be dealt with. At the beginning stage this will relate mainly to grants and any donations for the exhibition. You will need to know whether any income that you or your colleagues bring in will be additional to the budget granted to you, thereby increasing the amount of money you have available, or if it will be what is termed as 'budget relieving', that is, offsetting your costs and essentially saving the museum money overall. Often if income like this is classed as budget relieving a target will be set for how much income should be raised. If this is the case you will need to know what will happen if the target isn't reached. Will the museum still provide the full budget, or will you be asked to cut back? If the budget is dependent on this income, then it is better to assume a smaller budget and mark some things as 'nice to have' which you can add in later, should the fundraising be successful. Make sure to agree on a cut-off date for establishing the final budget with fundraising included that accords with the design process, and that after this date any additional funds that come in will be noted as budget relieving so that you will not be endangering your programme with last-minute design and construction changes.

Managing the budget

In order to manage the budget successfully you will need to understand, and adhere to, the way that your museum operates its own finances. If you don't already know, you will need to find out whether they run on a fiscal year basis (usually 1 April to 31 March) or on calendar years. Most exhibition projects last for more than a year, so make sure that you understand how the budget will be allocated. Will it be allocated in portions each year? What will happen if you haven't spent all of the money by the end of the year? Will it be automatically carried over, or will you need to apply for it to be reallocated to the next year? Does your finance department require you to accrue work, and how often do you need to report on this? Accrual calculations are when you estimate how much work of any contract has been done by the end of each year but not yet invoiced for. This ensures that the museum keeps the funds ready to pay when the invoices arrive and applies those invoices to the correct financial year. It can also help you if work comes abruptly to a halt, as it did for many during the COVID-19 lockdowns of 2020. If your accrual

calculations are up to date you can quickly estimate how much money you owe to each consultant and contractor for work done up to the date when work was halted.

Finally, make sure that you know how budgets are approved and who will sign off your budget. Record this, and who you have to report to on budget matters (such as any phasing across the year, or for the approval of large amounts of expenditure). Budget approval needs to be done formally and recorded in your project files. Set this up and save or print the relevant e-mails so that there is an electronic or paper trail.

Tips to help you estimate costs

Although every exhibition is different, there are trends, and you will need to do some research so as to have some numbers at your fingertips. The more familiar you are with exhibition budgets, the easier it will be for you to set up your budget and start to estimate costs more accurately. There are a number of ways to start getting a feel for how a budget should look. Most obviously, you should look back at previous exhibitions and do some analysis of the spend. How much did they cost? What proportion of this was spent on fees? Do you usually use external designers or do you have these skills in house? It is a good idea to get an idea of the percentage of the overall budget that you will need to set aside to pay consultants and other professionals to help you create the exhibition. Look at the amounts that were spent on objects and on loans. If you plan to loan in objects, you will need to get a feel for the different costs associated with this, which typically include:

- conservation condition reports;
- crates or packing materials;
- shipping costs;
- insurances;
- couriers' fees and expenses such as hotels and travel;
- mounts;
- costs for returning the objects at the end of the exhibition run.

By doing a thorough analysis of different exhibitions and breaking down object costs in different ways you will start to see what the average loan-in costs are and the difference it makes to loan an object from abroad. You may be lucky enough to have a registrar in your museum. If you do, then ask for their help in this task, as they will have a wealth of knowledge of the different loan costs and will also be able to advise about additional costs you might face for some international loans. Your curator will have a feeling, even at an

early stage, for where the objects are likely to be sourced from, so make sure to involve them in this part of the conversation.

You should also familiarise yourself with the costs for building or fabricating an exhibition. Take a look at past costs, and this will help you to understand how different designs will change the way the budget is used. Consider whether the museum often spends on new showcases or AV equipment. What does it have in stock that can be repurposed? How much does it spend on set works, as an average? What is the spend on graphics? Another helpful way of analysing the budget is to work out an average spend per square metre of exhibition. This, with a contingency added in, can often be a good way of proposing a starting figure for your initial definition documents (see Chapter 1).

If you are basing your cost estimates on previous exhibitions, do remember to add in some extra for inflation. The more ways you can cut and analyse previous budgets, the better. If your own museum doesn't regularly put on new displays, you can be sure that some of your colleagues in other institutions – or, if you are in England, your local Museum Development team – will be able to supply some of this information. Even if they are not willing to share detailed budgets, they may be open to sharing some of the key average metrics.

As you manage more exhibitions, start analysing your own estimates. How did your early cost estimates match up to those at the end of the project? Were you in the right ballpark overall? Often you can roughly estimate the cost of an exhibition based on an average cost per square metre, with extra added if there are some needs that you are able to plan for, such as new showcases or conservation work. But often you will find that the final apportionment of the spend will be quite different, as it will respond to the design. Don't let this worry you too much, as you can't second-guess design. But as you become more adept at estimating the overall budget, this will help you to assess whether the design is staying within the bounds of an acceptable spend.

If you are planning an exhibition in partnership with another institution or a touring exhibition you will need to make sure that your contracts with partners are very clear about the division of costs. Many costs should be shared, such as object preparation, which often includes conservation, framing or mounting. Likewise, any loan fees and transportation should also be shared. Some costs, such as research or producing a catalogue, are harder to split, so often an agreement will be reached with the partner institution as to who will do which pieces of work so as to balance the costs and make sure that the amount of time spent working on the exhibition is equitably apportioned. It is essential to agree this in advance of the work starting and

that the agreements also include how any incoming revenue will be apportioned. This should be done via a formal partnership agreement or contract.

Setting up the budget

You may have been given a budget to work to, or you may have a grant that sets the level of your expenditure. If that is the case you will need to be realistic about what you can achieve with that budget and be open with the designers about how much money you have available. In another scenario you may have start-up money to develop an idea which will then be costed and a budget will be developed as a result of this concept work. A third possibility is that you are asked to estimate how much you might need for your idea before you even get the designers or team on board.

If the exhibition will be large or complex, or if you are not experienced in exhibition management, it is a good idea to spend some of the budget on a specialist exhibition QS, who will know how much things cost and can advise on ways to keep costs down – for example, by suggesting alternative materials or pointing out where large sums are being expended so that you can judge where things can be trimmed back if it looks like you will be over budget.

Contingency

Whatever your situation, it is best to start by dividing the budget into a number of categories. The first category should be the contingency, a sum of money that you set aside and try not to touch. Ideally, it will be between 12% and 15% of your budget and you will allocate it to two pots – one for the design period and one for production. In this way you will know that you can allow the design team a bit more time if you want to explore a difficult design in more detail or if you want to develop a good idea that emerges unexpectedly. During the exhibition build, unexpected costs will always come up because, no matter how good your designers are, there will always be some changes that need to be made on site and that invariably will cost a bit more than you had planned. The more unknowns you have as you embark on the exhibition, the bigger your contingency should be.

Some institutions don't allow for contingency to be included in a budget plan, as it comes from a central pot. If this is the case, make sure when you put the budget together that you cost for the worst-case scenario for those lines that you are unsure of or where there are unknowns. For example, there may be a projector in the museum store and you may know that you are likely to need a projector for the exhibition – but for the purposes of the budget,

include the cost of a new projector. It is always easier to hand some of the budget back at the end of a project than to request additional funds. However, don't go overboard and start padding everything out, or your budget will soon start to look unrealistic.

Production

The second category to which you need to allocate funds is the production of the exhibition. This can be broken down into two parts: the large lump sum that you will probably pay a professional exhibition installation company to fabricate and build the show, and the costs that the museum will incur as a result of producing the exhibition – the 'direct costs'.

Installation

As you progress the design you will be able to add more detail to this category by listing out costs such as set works, installing the lighting, AV, sound and graphics. A large contract may go to a showcase manufacturer or, if you are reusing showcases, for someone to put them together, create new base boards and if necessary overhaul the lighting. You will need to create budget lines for all the elements that will go into the exhibition space. Consider what sorts of things you may need to create so that the exhibition fits your idea.

Remember when putting together the outline budget you are not designing the exhibition – so don't try to imagine set works or AV, but return to your interpretation plan (see Chapter 3), think about the focus of interpretation and make sure that you set aside budget for that. For example, if you have many incoming loans, will you need new showcases that meet government indemnity standards (this scheme is available to museums in the UK and is run through the Arts Council and provides an alternative to the cost of commercial insurance, see Online resources for more information), or will you be able to use what you already have? Will those objects need special mounts? Will your exhibition require lots of set works, or will it mainly rely on beautiful lighting of key objects? Do you need to set money aside for AV – perhaps a soundscape, audio guide or interactive features – and does the museum have the equipment for these elements or will you need budget to buy or hire it? What proportion of the budget feels appropriate, in comparison to what you are spending on the objects? Look back at previous exhibitions in your museum to see what was spent on these different elements. Will your show follow a similar distribution of expenditure? Remember to set aside a proportion of the budget for graphics, which may include labels, panels and something for larger-scale or environmental graphics which may be needed on set works.

Once you have listed all the elements needed for the show, you will have an idea of the scale of works that need to be budgeted for. At this stage you probably won't be able to assign a figure to each element; as a rough estimate, based on your research, start by assigning a percentage of the overall budget to the build element. Then, as the design begins to develop you can start to apportion the build budget between the individual elements, and perhaps even delete some from the list.

Museum costs

The other part of the production budget is the costs that you will need to keep to one side in order to support the development of the exhibition but that aren't part of a larger construction contract. These are the direct costs, or the costs that the museum will incur as a result of putting on the show. Will you need money for conservation work? Will you need to pay for transporting loans? What amount should you set aside for image licences (something that often costs more than you might think!)? What other materials do you think the museum may need to buy to make the exhibition come together? Ask your colleagues to help. What do they need? If you will be producing a schools' pack, will that come out of your budget, or does the museum have a schools or education team that has some funds for this work? The museum map will need updating. Again will you need to pay for it, or do the operations team or front-of-house team have a budget for updating it? Do any staff costs need to be accounted for? Does the conservation team need additional materials? Do any of the objects require specialist materials or environmental monitoring equipment? Make a list of everything that you can think of and mark these as your direct costs.

Here is a list of common direct production costs that you may want to consider, or to check whether they should form part of your budget:

- research funds such as travel expenses and subsistence costs (there may also be fees if you require the services of an external academic or curator), image licences;
- administration costs such as printing, postage and the production of samples;
- object-related costs such as loan fees, crates, transport, mounts or frames, insurances, conservation, condition reports and, if needed, artists' commissions;
- any public programmes related to the exhibition, which could take the form of lecture series, family workshops, leaflets or trails, schools packs and/or teachers' notes;

- catalogue costs, made up of author's fees, photography, production and distribution;
- additional front-of-house team members once the exhibition is open – e.g. you may need additional security staff, especially if you are using government or federal indemnity schemes;
- PR and marketing;
- opening events;
- de-installation costs.

Fees

Finally, turn to the fees. What professionals will you need? Designers, both 2D and 3D, are most likely to be needed and you may also want a QS; but who else? If your museum is large, some of these professionals are likely to be available in house. But consider whether you need a lighting designer, an interpretation specialist, a researcher or an AV producer. Will you need someone to provide accessibility or sustainability advice? Is someone available in house who can design the electrical changes needed to get power to new showcases or lighting? Will you need a structural engineer to advise on floor strengths and showcase weights? Will you be carrying out any visitor evaluation? List all of these people under the heading of fees. Working out how much budget to set aside for fees can be tricky, as many of the professionals base their fees on a percentage of the overall build cost. For example, a large design firm may charge between 10% and 20% of the build budget to design the exhibition, with other professionals charging between 3% and 7%. Again, your research into the costs of previous shows should help to confirm whom you might need to hire and what level of fees your museum commands.

Running the cost plan

Once you have set up the budget and divided the overall total among the different categories, you can set up the cost plan. This plan will be your way of tracking expenditure and keeping an eye on progress throughout the project.

Figure 10.1 opposite is a template showing how a section of a cost plan could be laid out.

Start with a column to record your original estimate that was signed off as the initial budget – this is labelled 'Agreed budget' in Figure 10.1. This can be divided down into year if the project requires this. Depending on your museum's finance rules, you may need to seek approval for changes if you want to move funds between categories such as fees and direct costs, so recording the original estimate is essential. It is also useful to keep this as a

Exhibition A								
Total Budget	250,000		Date cost plan last updated xx/xx/xxxx					
Date approved	dd/mm/yyyy							
			AGREED BUDGET	**FORECAST**		**AMOUNT COMMITTED**		
DESCRIPTION	**SUPPLIER**	**ORDER NO.**	**TOTAL**	yr 1	**TOTAL**	yr 1	**TOTAL**	
SECTION A - CONTRACTS								
Build contract	Exhibition build company A	ON 001	£30,000.00	£30,000.00	£30,000.00	£30,000.00	£30,000.00	
Showcase contract	Showcase company A	ON 002	£15,000.00	£17,000.00	£17,000.00	£17,000.00	£17,000.00	
					£0.00		£0.00	
					£0.00		£0.00	
TOTALS			£45,000.00	£47,000.00	£47,000.00	£47,000.00	£47,000.00	
SECTION B - FEES								
TOTALS								
SECTION C - DIRECT COSTS								
TOTALS								
SECTION C - CONTINGENCY								
Design contingency			£5,000.00	£5,000.00	£5,000.00			
Build contingency								
TOTALS			£5,000.00		£5,000.00			
PROJECT TOTALS			£50,000.00	£47,000.00	£52,000.00	£47,000.00	£47,000.00	

Figure 10.1 *Section of a cost plan* (based on the template used by Historic Royal Palaces)

reminder of what your original assumptions were, so that if you decide to move funds from one area to another, such as AV, you will have a record and will be able to see how this may affect some of your other budget lines.

Add a column to show what you think the final costs will be (your forecast). You will be able to fill in this column with greater accuracy as the design progresses and it will provide a ready reference for how the expenditure may differ from your original estimate. You can divide this column into yearly sub-columns if the project will run over more than one financial year, and divide up where you think the costs will land. This will help with any phasing or forecasting of spend.

Create a column for money that you have committed. Every time you raise a purchase order or agree a sum in a contract, record it here in this column under the relevant year. This way you will start to see how the project is developing and what your liabilities are at any given time. It is useful to also include a column where you estimate how much work has been done towards the completion of an order or contract. This can be another way of tracking progress on the project and is invaluable at year end if you need to do accruals. You will need to update the column each month and to think about how you will estimate work as completed. When you commit the money, what will mark the work as complete – will it be deliverables such as design documents, delivery to site of certain items? Make sure you include clear payment schedules in purchase orders or contracts to indicate the milestones that must be reached in order for a payment to be made, so that both you and the contractors or consultants are clear as to what needs to be done by when and the drawdown of funds.

Finally, create a column to record what you have paid out, so as to keep track of what has been completed and paid for. Often, you won't be invoiced until sometime after work has been completed. This is where the estimate of work completed column comes in handy, because if you know that something has been delivered but has yet to be paid for, this column is the only way to record the matter on your cost plan. If you go on holiday or leave, then others can see that the work has been completed and will know that, should the invoice arrive, it is good to be paid.

In the UK, many goods and services are subject to Value Added Tax (VAT), but museums that are registered as charities are either exempt or partially exempt from paying it. Find out what your museum's status is and ensure that the cost plan reflects this by recording the costs as either exclusive or inclusive of VAT. If the museum has a partial exemption it may be simplest to create a line at the bottom of the cost plan where you apply the appropriate percentage to the totals of the columns to which it applies.

Managing the budget

Once you have estimated the costs, set up the budget and created a cost plan, you will need to think how you will manage the budget and what this management can tell you and help you with as PM. Well-run budgets can inform you of project progress – who is delivering on time, who is due to deliver this month, what is going to plan and what needs attention. How will you manage changes to the budget (see below), and what circumstances will mean that you must dip into your contingency?

To keep the cost plan relevant, ideally, you should enter each purchase order or contract into the cost plan as it is created, or, at the very least, save them up and enter them into the plan once a month. At the end of each month look at your programme and think how far along you should be with each task; compare that to the amount of money leaving the budget or estimated as work done for those tasks that have a cost associated with them. Do they match? If not, why not? Is there a problem? If you think there may be a problem, with whom should you talk to find out what the delay is? Conversely, if the money is going out faster than you expected, check whether there is an overspend on anything and whether whoever is doing or managing the work concerned is talking to others and is aware of the overall programme. Review what you think the final costs will be, and then make any necessary adjustments to budget lines to reflect this and balance the books.

If you find that costs look like they are starting to run away, don't panic. Take a step back, identify the source of the overspend and call the project

team together to consult about it. You can take a number of steps in these circumstances. If you are in the design stage of the project you may want to look at reducing its scope. Go through the briefing document that you gave to the designers and see where you can trim back. What is looking like it will cost more – set works, graphics, AV, objects?

Cutting and compromising

Compromises can always be made. Perhaps you need to reduce the number of AV components. If the curator has specified particular objects from distant lending institutions, talk with them to see if a more local option can be substituted to keep costs down, or if other objects can be sacrificed so as to keep within budget, bearing in mind that there are huge financial and environmental costs in transporting objects. Curators naturally want the best objects for an exhibition, but are there some areas where compromises can be made? Sometimes it is the more unexpected objects that make your exhibition shine. You may need to make a tough decision and reduce the overall content of the exhibition. Are there areas of the interpretation plan that could be trimmed or even cut? Keep all the options open and be ready for some difficult conversations with your team about what can go. When the concept design comes in it is a good idea to get agreement from the team as to what are the 'must haves' and what are the 'nice to haves' in the design. Keep an eye open for elements that are risky, such as new technologies or things that the design team understand but that your audience may not notice – avoiding gimmicks will save money and make the exhibition or display more robust.

Once you start receiving prices for building the exhibition you may need to look again at cost cutting. Talk with the contractor about materials. Is there a cheaper alternative? Can you see some samples so as to judge if a change in quality will really affect the overall ambition? Ask the contractor where savings can be made, as they will know and can help to reduce hidden costs within the design that you may not have spotted. If you can, get the contractors in as early in the process as you can, as their input into the design and the best, most economical and most sustainable way to construct the exhibition will be invaluable.

On larger projects the QS and external design team should be able to suggest where savings can be made and help with the value-engineering process. The key aim of value engineering your exhibition will be to try to maintain the key deliverables and story line while still finding savings, by looking at construction methods, choice of materials and possibly alternative forms of media to deliver the information.

Change control

An important aspect of cost management is the system you put in place to manage and approve changes. During an exhibition project, especially during the build phase, minor changes will come along thick and fast. Unless you have a robust system in place for monitoring these, the cumulative cost of variations can be hard to keep track of – and the last thing you want is a surprise charge at the end of the build process. So, be prepared in advance so as to avoid unexpectedly going over your budget.

Changes during design

During the design phase of the project you will have set out dates for the delivery of each phase – concept, scheme and detail (see Chapter 2). You will have a contingency ready, hopefully something in the region of 12% of the budget. Keep around 2–5% of that contingency for design changes or developments. If you require a change after a stage has been signed off or after a design freeze (usually partway through scheme design), then you will probably need some budget to pay for it.

Be open with the design team and discuss with them any changes you need – you may have found that you can't get electrical power to the place where they wanted to put a lighting feature, or the project board or senior management team may have a strong objection to the colour of the walls that they didn't voice at the moment of sign off. Explain the reasons to the design team and find out from them what the implications will be for the design and the programme, and whether the change will incur a cost in extra design time.

Depending on the type of change you are requesting and the way that the design team work, not all changes at these stages will incur a cost from the designers. The designers may have allocated a certain number of days to the project and still be within that; or you may be asking them to work beyond what they have agreed, and so they will want to be recompensed for this time. Either way, it is important that you record the change and note any implications for the programme (time), the cost or the quality. Usually, changes have to do with improving the quality or reducing the cost. On some rare occasions you can do both with one change, but improvement changes generally come with additional cost, especially after the concept design stage. Add any change into your cost plan, clearly marked as a variation and as coming from your contingency – and remember to reduce the contingency line accordingly. It is a good idea to record each change on a change control form, where you can record the reason for the change and details about it (Table 10.1 opposite).

Table 10.1 *A simple change control form*

Change number	001
Requested by	
Date of request	
Detail of change requested and justification	
Effect on cost	
Effect on programme	
Comments from designer	
Comments from contractor/fabricator	
Comments from design team (if needed)	
Approved (note if this was not a decision taken by PM and link back to the decision register)	Yes/No
Date	
Project manager's signature	

Changes during installation

Once you get on site, keeping on top of the changes becomes a task that you as PM will need be on top of. You will need to be present on site every day if you can, or at least once a week for a longer and larger project. You should be very clear that you are the only person who can approve any change, no matter how small. Approving a change is different from deciding that it is a good idea. You will still need to consult on the changes with the design team and, if a change means going over budget, it will need to be approved by your project board or senior management team. Some museums may require any change that uses contingency to be approved by the project board or senior management team.

Changes always come up during the build or installation of an exhibition; what looks perfect on a drawing often needs tweaking when you are in the space. For example, you might realise that you need an extra piece of false skirting to hide a wire – this would be a change to the design that would need recording. Get to know your installation team and the fabricators (and for more about your role on site, see Chapter 6). Check the drawings as they come in for approval. Are the designers requesting any changes in response to what is coming in from the fabricators, for example, are the contractors suggesting a trade paint but the designers want a specific branded colour? This might be

termed a clarification: the contractor is asking if the designers are happy with the trade colour but if they aren't and insist on the brand colour then this might have a cost. Talk with your contractor and check if these changes will make a difference to the cost? If in doubt, ask. Record each change that comes, together with the cost, just as you did in the design period, this time making sure that you get comments on the effect on the design, programme and quality from all those involved – the builders, designers, curator (if relevant) and interpretation specialist.

A final word on cost control: the larger the project, the more likely it is that you will need help in managing the finances. It can be an almost full-time job reconciling your plan each month, raising orders and keeping track of changes. If you have staff available who are learning about project management, get them involved. The assistance of a project support officer can be invaluable in keeping the documentation under control and will make your job as PM that much easier.

Let's summarise

The following key steps will help you to manage exhibition costs:

- Make sure that you understand your museum's way of managing budgets.
- Know what is expected to be included in the costs and be very clear about what you are responsible for.
- Do plenty of research into past displays and exhibitions so as to get a feel for where expenditure generally goes. Do this both internally and with advice from colleagues elsewhere in your sector.
- Talk to your team and use their expertise to help you estimate costs, and include everything that will be needed.
- If you have a larger or more complex project, consider getting help from a professional QS.
- Make sure that you have a healthy level of contingency budget.
- Separate your costs into professional fees and production costs, further separating the production costs into contracts and direct costs.
- Set up a cost plan which will allow you to see at a glance how much money you have committed and how much work has been done.
- Use change control to ensure that costs don't run away and that you are in full control of expenditure and use of the contingency. Make sure that you communicate how it works to the whole team and that you seek approvals for spending the contingency if this is necessary.
- Try to secure some support for administration of the finances.

- Update your cost plan at least weekly/monthly during busy periods. During a project I generally have the cost plan open on my desktop most of the time – but see what works for you.
- Don't try to manage the budget by yourself. Share information on costs with your team and make coming in on budget a goal that everyone is working towards.

Top tips from Nick Gold, director at PT Projects

- **Budget**. Early understanding of the available budget is key to ensuring that design development time is not wasted on developing an unaffordable scheme – which may not only result in wasted fees but also lead to pressure on the overall programme.
- **Cost planning**. It is never too early to ask for advice. On more complex projects a quantity surveyor with good exhibition experience can help you from an early stage to set appropriate budgets.

 Remember when budgeting that the cost information you are using as a reference is historic and that the older it is, the more likely that cost will have changed. Always allow for bringing costs up to date. If the project is not likely to be on site for some time, you should also include an allowance for construction cost inflation.

 Regular reviews of the design as it is being developed, not just at the end of a design stage, can highlight any likely changes and help to manage the effect these may have on the budget.
- **Cost control during construction/fit-out**. Keep an ongoing record of all known changes and their cost effect. Remember that changes are not always issued via an instruction; ensure that you also monitor other information issued during the construction phase, as what might be assumed to be a clarification may well be a change with a cost effect.

 If possible within the time frame, always request a quotation for a change before it is instructed. If this is not possible, an approximate order of cost is always useful.

 If you have employed a quantity surveyor to advise on the likely effect of variations to the construction/fit-out works, ensure that you meet with them regularly and incorporate their report into you overall budget.

CHAPTER 11

Understanding and Managing Risks

Introduction

This chapter is all about how to manage the problems that come up when you are managing a project. Some of these you will be able to resolve easily; others will require a team effort. The cornerstone of good project management is to have a system to record and deal with risks, and to anticipate and plan for them. No project is risk free and no project ever goes entirely to plan. From elements you may have forgotten about in your project plan, to issues that arise when you are on site that you haven't accounted for, something will go wrong, but you won't have failed if you are prepared and have set up, in advance, a way of dealing with these issues.

Risk appetite

Before you can manage the risks on your project you will need to understand the museum's attitude to risk. Just as in personal life, each museum will have a different appetite for taking risk and different ways for dealing with and planning for changes that come its way.

The coronavirus pandemic that hit in spring 2020 put a severe test on all museums, but those that had considered how they would cope in a crisis and had systems in place to help them manage this sudden and unexpected change were able to adapt more quickly to the shocking effects of sudden closure. The effect of the pandemic was such that no risk management plan or crisis plan worked perfectly. The devastating impact of months of closure was not something that any institution could adequately guard against and led to inevitable but heart-breaking decisions to make staff redundant or, in some cases, close the doors permanently. The lesson here is that you can't plan for every eventuality, but you can plan for how you will react if the worst happens. Having good documentation in place throughout the project will help you if something unexpected does happen. If, like during the

coronavirus pandemic, you are forced to stop operations on site for a period, you will need to know exactly where you are in your contracts, how much work has been completed and what money is owed to all your suppliers and contractors (see Chapter 10).

If you don't know much about your museum's attitude to risk and how it plans around this, then ask. Do some research, find out if there is a corporate or museum-wide risk register and what sorts of things are on it. Discuss with your manager or board how much experimentation they want to see in your projects; for example, would they be happy to invest in new technology? What are their views on presenting controversial material? Does the museum have a statement about inclusion and diversity, and what are the goals around this? What are the board's views on sustainability, and how much risk do they see in not producing sustainable and ecologically friendly exhibitions? What will they invest in to make sure that your work is as sustainable as possible, especially for temporary shows?

All this adds up to a picture of how risk hungry your museum is. You may find that the trustees or senior leadership team are very risk adverse. If this is the case, you will need to start thinking about whether you want to challenge this and champion the reasons why taking more risks could be beneficial. Doing things differently could attract new audiences, generate publicity or even open up new funding streams. Not adapting or changing is also a risk. Your audience may find your new exhibitions stale, you may not be addressing the issues that are current and the museum, even with new exhibitions in place, might start to look old fashioned or out of touch with current attitudes.

Experimentation

Changing or short-term exhibitions can be a good place to start experimenting and taking more risks, because by producing time-limited shows you can be more agile and respond to feedback more quickly than you might be able to do in the permanent galleries. However, as Dexter Lord and Lord argue, museums should also think about how they design their permanent displays and work to make these more flexible, because completely static, expensive installations can quickly go stale and provide little opportunity for you to make changes that can provide a reason for repeat visits (Dexter Lord and Lord, 1999, 22). Some larger museums use exhibitions as a place to experiment, and, no matter what your museum's size, you can too. The British Museum has a small gallery to the right of the main entrance (Room 3) which is used for quick-changing, free exhibitions, usually focusing on one or just a few objects, and which is designed to test new curatorial thinking or interpretive techniques. It brings repeat visitors to the museum, but it also

provides the interpretation team and the curators with an impressive body of knowledge on how visitors react to the displays, the results of which can, if successful, be transferred to larger shows. You can try this as well. By prototyping, or even by just changing the labels of a few key objects, you can test new ideas and measure the risks and benefits of doing this on your audience. If the museum is risk averse, this type of low-cost experimentation and visitor surveying can help to build a case for change.

Case study 11.1: Room 3 at the British Museum

Claire Edwards has been interpretation manager at the British Museum since the interpretation team was created and was part of the team that worked to deliver a new approach to the display of galleries and exhibitions at this major national institution. She notes: 'Using Room 3, a space with a small footprint, as an experimental space for trying different approaches, we used our learning to change the traditional hierarchy of display and text, giving a stronger focus to narrative, high-level messages and engaging visitors emotionally and imaginatively, as well as intellectually.' In this smaller space within the museum, and with a rapid turnover of displays, the team were able to try out new theories and experiments, knowing that failure wouldn't have major consequences.

The team used Room 3 for a range of different displays, including testing how visitors read labels and panels. Claire recalls that in galleries at the time the high-level messages and narratives were carried on wall panels. It was assumed that visitors didn't really read the labels. 'In the "Samurai to manga" show (2005), we pushed this assumption to the limit,' says Claire, and proved that linking information closely to an object or group of objects engaged people in a way that more distant panels did not. One of the first galleries to emerge from this approach was the Japan gallery, paring back panels and using 'gateway' objects to deliver thematic displays within a chronological framework. This learning was then taken into the design for the Clocks and Watches gallery and Early Medieval gallery (for which, incidentally, I was the senior interpretation manager and benefited greatly from all this intensive visitor research).

Claire explains that the use of Room 3 as a testing ground over a period of more than 15 years has 'led to a greater focus by the teams working on new galleries and exhibitions on the needs of visitors, more understanding of what engagement might look like and how to be more flexible and playful with ideas'. Shows started to become more experimental, including displays of Japanese flower arranging known as ikebana and the introduction of a replica Egyptian cat sculpture with different messaging applied to find out how it changed visitor behaviour – did they stroke it or not?! Claire says that 'these and other experiments illustrated how learning can happen in unexpected ways if you create the right environment. In short, it led the team and the museum to start to move away from the traditional and more didactic style of the past.'

'More recently,' Claire reveals, 'Room 3 has been used to work with communities and to test broader ideas on contemporary and resonant themes such as migration and refugees, collecting and colonialism, waste and national borders, with the museum looking to better understand visitors' responses to challenging themes.'

Room 3 is a great example of how a museum is taking controlled risks to improve its overall practice.

Understanding risk

Once you have established how much risk your museum is willing to take, you can assess where your project falls on its risk scale. If it is a continuation of previous styles of exhibition, then the risks involved in its implementation are likely to be low. You will be able to learn from the past and adapt to and cope with changes that come up, as they have probably been faced by the team before, but the risk of becoming stale or not attracting new visitors may be higher. If you haven't done an exhibition before like the one you are planning, or if the space is one you haven't used for exhibitions in the past, the risk levels will be higher. If your museum is new to exhibitions, is entering into a partnership for the first time or is attempting to change the paradigm of the museum through a new display, perhaps through community collaboration or discussing controversial materials, then the risks may be higher still. If you have several projects on the go, you may want to give each one an overall risk rating out of five so that you know where to focus your risk management. If you do have lots of projects on the go, it is useful to have an overall reporting mechanism that will show you at a glance the progression of each project and highlight any key risks.

Types of risk

There are different kinds of risk that you will need to consider for your project, including the following:

- **Reputational risk**. This is when something in your project may put the reputation of your institution at risk. This risk could come from the content of your display. For example, after the killing of George Floyd in the USA in 2020, and the global support and recognition of the Black Lives Matter movement, many museums responded by changing the way they investigate history, adapting their displays to illustrate areas of history that had previously been under-represented and increasing their efforts to understand, recognise and respond to the contested history of their collections. In some cases this work has taken on a political edge, which lead to both a positive and a negative press. Such risks, and how you will protect your staff in the face of any social media backlash, need to be considered as part of your risk management. Other reputational risks may lie in how you care for objects: lenders need to know that your museum is a trustworthy and safe place. If its environmental controls are poor or the cases are below standard, this can damage its reputation with potential lenders, making it harder in the future to secure the objects you want for your exhibitions. There are many other risks like this, and it is

your duty as PM to compile and analyse them, noting those that may occur within the bounds of your project and that would affect the delivery or success of the exhibition.

- **Business risk**. Many museums are reliant on their visitors for income, whether this comes through ticket sales, merchandise sold in the shop, sales in the café or donations. You may well have to write a business case when putting together your project definitions (see Chapter 2). The business case may include financial targets. Not reaching your income or visitor targets would be a risk to achieving project success.
- **Completion risk**. There are many reasons why you might end up not completing a project, and these need to be considered. Lack of funding, inadequate staff time, failure to secure loans are just a few of the risks you need to think about and include in the risk register.
- **Not meeting goals and objectives**. This is self-explanatory, but again you need to think about the risks of failure in these areas and how you will work to mitigate them. In order to analyse these risks you will need to have set clear goals and objectives (see Chapters 1 and 2 for more information).
- **Specific project risks**. Each project is unique and will have risks that relate only to that show. These risks may be around content, the space where the exhibition is located, the time of year that it takes place or competing exhibitions or events in the local area.

Box 11.1: The difference between a risk and an issue

One of the common misunderstandings that arises when setting up a way of dealing with risk and looking at mitigations is the difference between an issue and a risk. Getting these clear in your mind will help in your management of the project, otherwise there can be confusion in the use of budgets and the time taken trying to resolve matters.

The simplest way of differentiating between the two is to think of issues as things that are happening now, whereas risks are problems that might arise. Things can move back and forth between the two, but the distinction is important because you should be focusing the majority of your time on risk management to prevent issues arising. If (and when) issues do come up, you will have in place well thought-through mitigations and a clear decision-making path to manage them quickly and efficiently.

Having the right approach

Talking about how things that can go wrong and admitting that there is risk to what you are doing takes some courage and honesty. All too often, risk management is overlooked, either because staff don't want to share their concerns or because there is a blame culture where, instead of focusing on managing problems and finding solutions, the emphasis is on interrogating why something has gone wrong and punishing those deemed responsible.

If you find yourself managing a project in a situation where a blame culture has been the norm, you will need to work extremely hard to build trust and start changing perceptions around how issues and risks are dealt with. Lead by example, admit when something has gone wrong, say sorry if you made a mistake, note how you would do things differently if you could and move on to a solutions-focused approach. As a PM you will need to build a reputation for being trustworthy and dependable, not someone who shouts when things go wrong or panics at the first sign of trouble. You will need to balance this with fairness, because your ultimate responsibility is to the project. To make the project a success, you won't be able to please everyone all the time, you will need to learn to say no, to stand your ground firmly and politely and to make sure that you think about what is best for the museum and the project rather than giving into demands or shying away from making difficult decisions. This is not an easy balance to strike; you will need to learn what battles to fight and what you can let go. You will sometimes get it wrong, but, over time, you will learn. You can be a great PM and a nice person! People will respect you more if you listen to their concerns and issues and if you can clearly explain why you are saying no to something that they hold dear.

Overseeing a project can be a lonely experience if you don't take the time to build up some team spirit and foster collaborative working. Invest time in accompanying your team on trips to see other museums and gain consensus on what works and what the team like in terms of design and interpretation. Find out more about their passions for the work and share with them your own. During the high-pressured installation period you will all need to work together to reach the opening date successfully, so put in the time early on to build the relationships you will need later – after all, we all spend a lot of time at work, and it should be enjoyable!

Setting up a risk register

Every project should have a risk register (Table 11.1 opposite). This is essentially a list of everything you can think of that *might* go wrong with the project or that could stop it in its tracks. This is not something that you as PM can do alone, and you will need the input of the whole team.

It is a good idea at the outset of the project to hold a risk workshop. This can be quite a depressing exercise, and providing some good refreshments or following it up with a visit to see another project can help with motivation.

In the workshop you will be asking people to first think of all the things that could go wrong in the project. If you have a large team you could divide it up into groups, putting those who work on similar tasks together so they can work through their process. Sometimes it works well to compile the risks

Table 11.1 *Example risk register entry*

Description of risk	Likelihood	Severity	Overall risk score	Effect	Mitigation	Action by
Key loans from lender X not granted – not that likely as good discussions already held	3	4	**12 (amber)**	Main narrative will require rethinking, may affect quality if our own collection is used, or cost if objects need to come from more lenders	Project team to work up an alternative narrative using our own collection/ more lenders	Loans manager and curator

at the same time as you are putting the programme together, so that you can think through each stage of the project systematically.

Listing all the risks is just the first step. Armed with the list, you will need to think through the likelihood of each risk actually happening, and this is best done in the risk workshop. For example, if one of the risks is that the exhibition will be based around a group of objects that you need to loan from one lender but you are not sure that you will get permission to borrow them, you will need to consider how likely this is. Perhaps you have already had some outline discussions with the lenders and, although you haven't yet got a formal loan agreement in place, you are actually fairly confident, based on those discussions, that the loans will come through. If that is the case you can give this risk a low probability score. I generally like to keep things quite simple and give scores out of five, with five being the highest or most likely to happen and one being the least.

Now you need to consider what the impact on the project would be if that risk happened. Using the example of the loan, the impact would be severe. Mark this out of five and then multiply the two numbers to get an overall measure of the risk. You can then categorise the risk as high, medium or low and add a colour to correspond to this, using a traffic-light system. If you want to go deeper for each risk you can give it a score against the impact it would have on the time, quality or cost of the project, or you could simply note whether it would have an effect on these. All risks will have an impact on one of these three areas, and it's up to you and the project team to decide which of these three is more important to the project as a whole.

Consider what the effect of the risk will be on the exhibition. Using our example, it might mean that you have to rethink the main narrative. Make sure to record this in the risk register, because in some rare circumstances you

may find a risk that is so serious that it would mean stopping or postponing the exhibition, and if that should happen you would want to be fully prepared.

Think next about what you can do to manage the risk – that is, the mitigations you can put in place now or at the time when it becomes real to stop that moment turning into a crisis. In our example you might go for an alternative narrative, using your museum's own objects in place of the loans, that would hold up well enough to still make the exhibition a success. You should do some work to get this 'Plan B' in place now, as it is better to put in a bit of extra work when things are calm and not make use of it, than to be in a panic later on.

Actively managing the risks

The risk register should be a living document. Too often in projects the risk register is written at the beginning of the project and then set aside and not referred to again. As PM you should be actively reviewing risks, putting in place mitigation work and altering the scores of the risks as you go along. If your key loan still isn't agreed at the end of concept design for example, then you will probably want to increase the scores and start to have some serious discussions with the team about next steps. This is what risk management is all about: you are trying to ensure that, should something not go as expected (and believe me, this will happen), you are ready for it – calm and prepared to help the project team manage it and move on.

Some of this management comes down to having contingency. In Chapters 9 and 10 I have written about having some slack in your programme or extra budget set aside for those moments when you suddenly need to change the plan. In the risk register you can plan for this by including a commentary about what the effect of the risk would be on your golden triangle of quality, cost and time (see Figure 2.4). It is the PM's role to balance these three key elements of the exhibition, and how you approach risks is a big part of this.

Returning to our example of loans, you may consider that swapping from the star loans to objects from your own or another collection would have a detrimental effect on the overall quality of the exhibition and may slow you down a little, but you can mitigate for this by having the 'Plan B' ready in the background, which may in fact provide some opportunities. For instance, it could save rather than cost you money, as it could eliminate or reduce transport costs, conservation costs and some insurances. You could even give those three elements ratings of their own and traffic-light colours so that you are fully aware of what you might be facing.

Defining risks

Risk management is about being collaborative. You will find solutions to risks or even become aware of them only if you are working collaboratively as a team. Your team will have a broad range of experiences and skills which can help you and them to identify where the risks are and reach a consensus about the level that should be assigned to each risk. You will find that different members of the team have differing attitudes to risk, and at different times throughout your life you will have different attitudes to risk, as will your project team members (Dohmen et al., 2018). This is why the rating of each risk in your risk register should be agreed on by the team. With your team, you need to try to identify the root cause of any risks. In our example regarding loans from a single lender, the root cause might be overreliance on a particular lender, or perhaps even a lack of appetite to explore other topics, objects or lenders. Why is this? Unpick this risk as far as you can in a risk workshop. With some fresh thinking, and additional support from the curator, you may even be able to reduce or eradicate it.

Identifying mitigations

When thinking about mitigations for the risks you come up with, it can help to think about the principles of disaster management. The four key principles are:

- preparedness
- damage reduction
- intervention
- improvement.

Not all of these will be appropriate for your risks, but they can help. For example, how prepared are you to change the narrative of the exhibition, and is this even possible? What interventions are you willing to make into the team's work to steer them away from overreliance on a single lender? What improvements could be made to ensure that the team have the time and space to consider other lenders? Do they need the services of a part-time researcher, and would this be a good use of project money to mitigate the risk? Finally, should all of the above not be options and the lender be unable or unwilling to lend, how will you limit the damage this causes to the project? Ideally, you would have aimed to secure a loan agreement before any serious work on the project even started, and certainly before any money had been spent on engaging consultants or designers.

Risk Management

Once you have drawn up your initial risk register it will be time to take it to your project board or senior management team and test their risk appetite. If you find that the exhibition has lots of red risks you will need to analyse this and try to understand if there is an overall underlying problem. For example, you may find that the team have come back with a lot of risks concerning the time available to complete the work. You will need to test this with the project board or senior management team. How comfortable are they with pushing the staff to get this done? Can they allocate more people to the project? Do they accept that with the number of red risks you have identified there could be a danger of not completing the exhibition by the dates set, or that other work that the team are expected to do will be delayed? Is there any possibility of shifting the opening date? Having these kinds of discussions is risk management.

We all do risk management all the time without really realising it. In a project scenario it is no different, except that it is formalised with a register and a slot on your regular team meetings to review and judge if anything has changed.

Dealing with issues

Once the risk register is up and running you will find that some things change from being risks into being issues. Issues will also be brought to you by the team, or will arise once you are on site. Alongside good risk management, careful issues management should help you to monitor what is happening and how you are dealing with it. Not everything that is brought to you for decision is an issue. I would define issues as being things that are either risks that are happening now or things that come up unexpectedly that put the project at risk in some way. For example, a risk may be that you might not be able to recruit an interpretation specialist for the project, but an issue would be if you had that person on board and then for some reason they were off sick for a number of weeks and you had to find a way to cover their work.

As PM you will find lots of decisions and questions coming your way, and you will need to analyse these to identify if any of them are risks or live issues. Many of the decisions you make when questions are brought to you don't need to be tracked and recorded, especially if they don't affect programme, cost or the quality of the final product. However, if something is brought to you and requires a decision to be taken that affects lots of people, it should be recorded (see Chapter 2 for information on setting up a decision register).

When you are working through the design process the sorts of issues that come up may concern loans, how visitors will access and flow around the space, and the cost of design. Once the design is completed, the nature of the

issues will change and may be about the length of time something takes to produce, or how easy it is to install something. Once you are on site you will probably find decisions and questions flying at you much faster than they were previously. This is when your planning for how to manage this will come into its own. It is at this stage that you will need to be clear as to when something is an issue or just the usual project management work. For example, a piece of showcase glass being too big to fit through the doorway to the gallery is an issue (hopefully, one that you won't face, as you will have identified the small doorway as a risk and provided measurements to all your manufacturers at tender time, as part of your risks management). A question about which material to use to cover a showcase baseboard is not an issue but a decision – although if there isn't agreement on this because it's not clear who is the ultimate decision maker, then this could turn into an issue.

Keeping track

Keeping a clear record of these issues and decisions, and keeping them as separate as you can, will help you to concentrate on the important areas that are a risk to the completion of the work, and at the end of the project it will be valuable information for evaluating your project management procedures. For example, if you had the issue of a disagreement about the type of covering for a baseboard, this could be fixed by improving your project set-up; it might also be that your RACI needs attention. You can learn from this, ready for your next project. (See Chapter 2 for how to set up a RACI document.)

A decision register (see Table 2.3) is the best way to keep track of what decisions you had to make on the journey to getting the exhibition completed. You can refer people back to this if they try to re-raise something that has already been decided; and should you, the PM, be off sick or away for any reason, it will provide a clear path for someone else to pick up where you have left off.

Every time someone asks you a question about the project, think to yourself, 'Does this need to be recorded somewhere? Is it a risk or is it an issue we are trying to solve?' Personally, I like to keep two types of document going: first, an action tracker, which is an informal list that I update from week to week with all the things I have been asked or on which I am waiting for a reply. Usually I create this in a spreadsheet, where I can 'hide' the cells for all the actions that have been resolved (it can get very long!). Usually I share this with core team members and they can also add information to it. I also keep a decision register as already described in Chapter 2.

Try to get into the habit of updating these documents as you go along, as they should be things that are useful to you and your team. If you find that a

particular document isn't working, consider why and whether it is needed for your scale of project. Much of project management is about finding the ways that work for you to keep track of all tasks, decisions and gateways and project milestones and ensuring that these all come together as they should. Documents and process can help you to keep track, but ultimately it is about having a good handle on what should happen, when, and having the confidence to step in when you see that something isn't working out as it should. If you are spending all your time on process, it's time to review it, because this isn't what your role should be about.

Let's summarise

In this chapter we have discussed the different types of risks you may face and how important it is to be prepared and to capture them so that when something does go wrong you are equipped and ready to deal with it, calmly and efficiently. We have discussed how to hold a risk workshop to gather risks, and the importance of involving the whole team in this exercise. We have looked at the differences between risks and issues and how to balance your time between them. Overall, the message here is to plan for the best but to prepare for the worst. Don't be afraid to talk about risks, and ensure that you take control of any issues that arise.

Tasks you should carry out to manage risk include:

- holding a risk workshop to identify risks to the project and score them for their likelihood of happening (probability) and the impact they would have on the project (severity). Consider time, quality and cost;
- drawing up a risk register to capture these risks and reviewing it at each project meeting;
- moving any risks that become live to an issues list and dealing with them accordingly;
- keeping a decision register and an actions list so that you are clear about how the everyday project work is separate from risk and issue management;
- continually reviewing and adding to the risk register throughout the life of the project;
- reviewing your processes regularly and making sure that they work for you and aren't just creating process for process's sake.

Summary

This book has briefly covered all the main tasks required to project manage an exhibition and the role of the PM in steering the project from a kernel of an idea to a show that is open to the public. On the way we have looked at setting up key documents to help with the management of this work, and taken deeper dives into some of the most important work that will contribute to the exhibition's success, such as getting the vision right, interpretation planning and design. We have also focused on the process for exhibition management using a five-stage process with clear gateways at the completion of each stage. In this final chapter I will sum up for each of the five stages the key tasks you need to undertake, the main outputs being created and the gateway questions you will be working towards answering.

Define

Work needed: In this stage you take the exhibition concept, analyse it, carry out formative evaluation and create a vision for the exhibition.

Output: An exhibition proposal, complete with the vision and 'big idea' for the exhibition, including the outline of its content, showing:

- how it is unique;
- how it will contribute to the overall museum vision and objectives;
- how it responds to visitor needs;
- what its goals are;
- what its objectives are (so these can be measured against at the end of the project);
- when it will happen (noting that many exhibitions take at least two years to develop and implement);
- images of key objects, and perhaps some quotes or interesting information about the subject to help sell the idea;

- some examples of the type of display, which will serve as creative inspiration for the team.

Gateway question: Is this exhibition something that you, the museum, want to invest in, and do you agree that it meets the museum's objectives?

Plan

Work needed: This is a stage which requires you, as the PM, to set up all the processes needed to manage the exhibition, alongside development by the design team of the concept for the show.

Output: A project execution plan that contains elements including:

- cost plan;
- risk register;
- programme;
- project structure;
- RACI;
- communication plan;
- decision register;
- sustainability, inclusivity and access information;
- concept design for the exhibition;
- key objects list/images;
- business case information such as the projected return on investment.

Gateway questions: Have we planned this exhibition as you, the museum, expect and is it the style of exhibition you want to see? Are you happy for us to continue and start spending more money on making it a reality?

Execute

Work needed: This stage requires constant updates and monitoring of the cost plan, of the risk and issue registers and of task completion by the project team, as well as use of change control. The design will be developed during the scheme design and detailed design stages. You will appoint contractors and complete any health and safety work, and the exhibition will be constructed and installed on site.

Outputs: This stage is one of the busiest, requiring several outputs to be completed in succession:

- scheme design;
- detailed design;
- appointment of contractors;
- health and safety plans, risk assessments and method statements;
- set build;
- showcase installation;
- installation of all exhibition elements, including graphics, AV, lighting etc. and finally, the objects.

Gateway questions: Has the exhibition been installed as per the designs? Is everything finished to a satisfactory and safe standard?

Transition

Work needed: This stage will see the completion of any changes in the rest of the museum to signpost the exhibition, as well as changes to the shop and café, if required, to fit in with exhibition themes. The museum's website will be updated to reflect the new show. Press and media work will be carried out in preparation for opening night/events. Training will be provided for front-of-house staff and an information pack will be prepared to support the show.

Outputs: This stage might be quite short but it is important to get right so that the transition from project to business as usual goes as smoothly as possible:

- operating and maintenance manuals;
- staff training and familiarisation;
- photography of the finished exhibition;
- 'cheat sheets' for staff using any equipment every day;
- press and media coverage;
- frequently asked questions pack and further information for staff supporting the exhibition's running;
- opening night celebration.

Gateway question: Is the exhibition ready for the visitors to use?

Closure

Work needed: At this stage you will close out the finances so that the project is financially complete; tidy up project files; and hold a review session with the project team. This is also when you will carry out evaluations: an internal evaluation on how the project went and an external evaluation to gauge the

reaction of the audience and compare this to the objectives set in the Define stage.

Outputs: The main outputs in this stage will be a set of reports on the performance of the project:

- a project report including a summary of how the exhibition performed against its objectives, any lessons learned and what processes need changing or reconsidering in the future;
- an evaluation report on how the visitors received the exhibition.

Gateway questions: How well did the exhibition perform against its targets? What lessons can be learned for the future?

Project management skills

We also investigated how, as PM, you gain the skills to manage the three main cornerstones of project management: cost, time and quality. Key skills to practise include attention to detail, how to listen and to ask open questions, cultivating a no-blame culture, building a team spirit and holding and leading a vision (not losing sight of the bigger picture).

Being a PM is about being a people person and a process person. It requires you to have a passion for your museum as well as superb organisational skills and the ability to thrive under pressure.

Running exhibition projects means that you will become involved in some highly creative and diverse projects, working with a huge range of talented people. Your work will be varied and ever changing. As I wrote in the Introduction, project management of exhibitions can be great fun. Try to learn from each project that you do and adapt any or all of the processes outlined in this book so that they work for you.

Good luck!

Bibliography

Beck, L. and Cable, T. (2011) *The Gifts of Interpretation: Fifteen Guiding Principles for Interpreting Nature and Culture*, Sagamore Publishing.

Black, G. (2005) *The Engaging Museum: Developing Museums for Visitor Involvement*, Routledge.

Black, G. (2012) *Transforming Museums in the Twenty-first Century*, Routledge.

Blockley, M. and Hems, A. (2006) *Heritage Interpretation: Issues in Heritage Management*, Routledge and English Heritage.

Brochu, L. (2003) *Interpretive Planning: The 5-M Model for Successful Planning Projects*, Interp Press.

Brochu, L. and Merriman T. (2002) *Personal Interpretation: Connecting Your Audience to Heritage Resources*, Interp Press.

Brown, A. S. (2005) The Charter: Selling Your Project, paper presented at PMI® Global Congress 2005, PA: Project Management Institute.

Dean, D. (1994) *Museum Exhibition: Theory and Practice*, Routledge.

Dean, D. (2006) *Exhibition Design*, Routledge.

Design Council (2019) Framework for Innovation: Design Council's Evolved Double Diamond, www.designcouncil.org.uk/our-work/skills-learning/tools-frameworks/framework-for-innovation-design-councils-evolved-double-diamond.

Dexter Lord, G. and Lord, B. (1999) *The Manual of Museum Planning, Second Edition*, Alta Mira Press.

Diamond, J. (2016) *Practical Evaluation Guide: Tools for Museums and Other Information Education Settings*, Rowman & Littlefield.

Dohmen, T., Falk, A., Golsteyn, B., Huffman, D. and Sunde, U. (2018) Identifying the Effect of Age on Willingness to Take Risks, https://voxeu.org/article/effect-age-willingness-take-risks.

Durbin, G. (1996) *Developing Museum Exhibitions for Lifelong Learning*, Stationery Office Books.

Falk, J. H. and Dierking, L. D. (2011) *The Museum Experience*, Left Coast Press.

Falk, J. H. and Dierking, L. D. (2016) *The Museum Experience Revisited*, Routledge.

Forster, H. (2008) *Evaluation Toolkit for Museum Practitioners*, Renaissance East of England, https://visitors.org.uk/wp-content/uploads/2014/08/ShareSE_Evaltoolkit.pdf.

Gido, J., Clements, J. and Baker, R. (2017) *Successful Project Management*, Cengage Learning.

Ham, S. H. (2013) *Making a Difference on Purpose*, Fulcrum Publishing.

Health and Safety Executive (2015a) *The Construction (Design and Management) Regulations 2015*, www.hse.gov.uk/construction/cdm/2015/index.htm.

Health and Safety Executive (2015b) *Managing Health and Safety in Construction: Construction (Design and Management) Regulations 2015, Guidance on Regulations*, Health and Safety Executive.

Hilton, S. (2017) *Transforming Future Museums: International Museum Academy Greece, Project Management Toolkit*, www.britishcouncil.org/sites/default/files/ima-project-management-toolkit_0.pdf.

Hooper-Greenhill, E. (1994) *Museums and Their Visitors*, Routledge.

Hooper-Greenhill, E. (1995) *Museum, Media, Message*, Routledge.

Kendrick, T. (2010) *The Project Management Toolkit: 100 Tips and Techniques for Getting the Job Done Right*, Amacom.

Kotler, N. and Kotler, P. (2007) *Can Museums be All Things to All People?* Routledge.

Lee, C. (2007) Reconsidering Conflict in Exhibition Development Teams, *Journal of Museum Management and Curatorship*, **22** (2), 183–99.

Murray-Webster, R. (2019) *APM Body of Knowledge, Seventh Edition*, Association for Project Management.

Newell, M. W. (2001) *Preparing for the Project Management Professional (PMP) Certification Exam*, Amacom.

Paddon, H. (2014) *Redisplaying Museum Collections: Contemporary Display and Interpretation in British Museums*, Ashgate.

Project Management Institute (2020) www.pmi.org/about/learn-about-pmi/what-is-project-management.

RIBA Enterprises (2013) *Guide to Using the RIBA Plan of Work 2013*, RIBA Publishing.

RIBA (Royal Institute of British Architects) (2020) RIBA Plan of Work, www.architecture.com/knowledge-and-resources/resources-landing-page/riba-plan-of-work.

Rogers, J. (2010) *Facilitating Groups*, McGraw Hill, Open University Press.

Roppola, T. (2013) *Designing for the Museum Visitor Experience*, Routledge.

Sandell, R. and Nightingale, E. (2012) *Museums, Equality and Social Justice*, Routledge.

Serrell, B. (2006) *Judging Exhibitions: A Framework for Assessing Excellence*, Left Coast Press.

Serrell, B. (2015) *Exhibit Labels: An Interpretive Approach, Second Edition*, Rowman & Littlefield.

Slack, S. (2021) *Interpreting Heritage: A Guide to Planning and Practice*, Routledge.

The Stationery Office (2009) *Managing Successful Projects*.

Tilden, F. (1957) *Interpreting Our Heritage*, University of North Carolina Press.

Tilden, F. (2007) *Interpreting Our Heritage, Fourth Edition*, University of North Carolina Press.

Wells, M., Butler, B. and Koke, J. (2013) *Interpretive Planning for Museums: Integrating Visitor Perspectives in Decision Making*, Routledge.

Online resources

Arts Council England: Inspiring Learning for All
www.artscouncil.org.uk/measuring-outcomes/generic-learning-outcomes#section-1

Arts Council England: Generic Social Outcomes
www.artscouncil.org.uk/generic-social-outcomes/importance-gsos#section-1

Arts Council England: Generic Learning Outcomes
www.artscouncil.org.uk/measuring-outcomes/generic-learning-outcomes#section-2

Arts Council England: Government Indemnity Scheme
www.artscouncil.org.uk/protecting-cultural-objects/government-indemnity-scheme#section-1

Association for Heritage Interpretation
https://ahi.org.uk

Morris, Hargreaves and MacIntyre: Browsing, Following, Searching, Researching
https://mhminsight.com/articles/browsing-following-searching-researching-2518

Museums Galleries Scotland: Planning Your Interpretation
www.museumsgalleriesscotland.org.uk/advice/collections/planning-your-interpretation

Project Management Institute: What is Project Management
www.pmi.org/about/learn-about-pmi/what-is-project-management

RIBA: RIBA Plan of Work
www.architecture.com/knowledge-and-resources/resources-landing-page/riba-plan-of-work

Theatre Green Book
https://theatregreenbook.com

Visitor Services Group
www.visitors.org.uk

Wessex Museums: Interpretation Plan Template
www.wessexmuseums.org.uk/resource-hub/frameworks-templates/interpretation-
 plan-template

Index